CREATING
SPECIAL EFFECTS

CREATING
SPECIAL EFFECTS

Published by Time-Life Books in association with Kodak

CREATING SPECIAL EFFECTS

Created and designed by Mitchell Beazley International
in association with Kodak and TIME-LIFE BOOKS

Editor-in-Chief
Jack Tresidder

Series Editor
Robert Saxton

Art Editors
Mel Petersen
Mike Brown

Editors
Louise Earwaker
Richard Platt
Carolyn Ryden

Designers
Marnie Searchwell
Stewart Moore

Picture Researchers
Veneta Bullen
Jackum Brown

Editorial Assistant
Margaret Little

Production
Peter Phillips
Jean Rigby

Consultant Photographer
Tim Stephens

Coordinating Editors for Kodak
Paul Mulroney
Kenneth Oberg
Jacalyn Salitan

Consulting Editor for Time-Life Books
Thomas Dickey

Published in the United States
and Canada by TIME-LIFE BOOKS

President
Reginald K. Brack Jr.

Editor
George Constable

The KODAK Library of Creative Photography
© Kodak Limited All rights reserved

© Kodak Limited, Mitchell Beazley Publishers,
Salvat Editores, S.A., 1984

Library of Congress catalog card number 127 1410
ISBN 0-86706-234-7
LSB 73 20L 12
ISBN 0-86706-233-9 (retail)

Contents

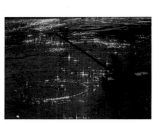
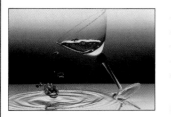

THE CAMERA AS CONJURER

Many photographers are content with realistic pictures that reproduce the world as we perceive it. And because we are accustomed to such photographs, when the camera does create illusions the results are all the more immediate and impressive.

This book unfolds the fascinating world of special effects photography, and explains some of the simple special effects that anyone can exploit to make memorable surrealistic images. The photographs on the following nine pages take reality merely as their starting point. They surprise us with their weird juxtapositions and symbolism, lead us into dreamworlds where time and space are haywire, or spin beautiful images with unearthly forms and colors. Yet none of these pictures would have been beyond the reach of the newcomer to special effects. For many of them, such as the haunting landscape opposite, the only requirement was a willingness to experiment freely with simple equipment and film. Others required a little more in the way of camera attachments, materials or props, but nothing that anyone could not easily make, buy or borrow.

The basic techniques covered in this book should stimulate further exploration. Learn to break the rules uninhibitedly. And do not worry if the results are unpredictable – this is all part of the pleasure of special effects photography.

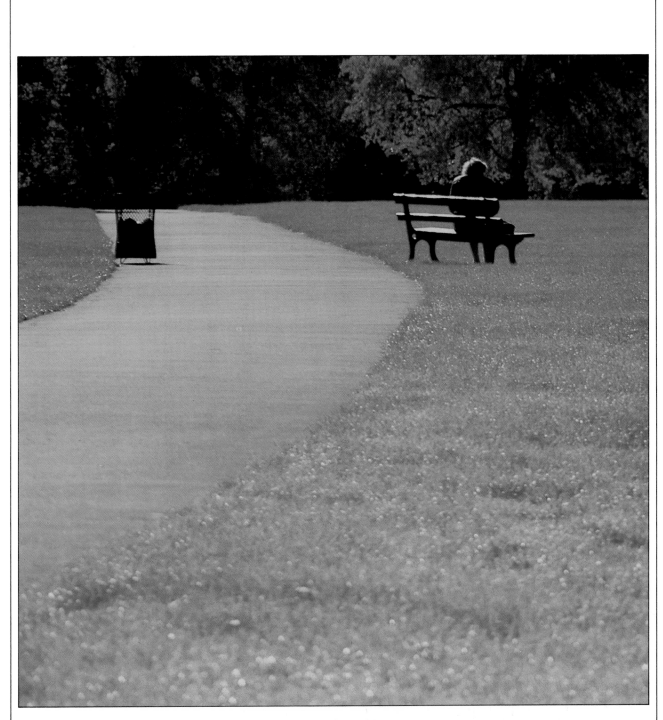

A tranquil park glows with strange, rich colors that create an autumnal atmosphere. The photographer took the picture on infrared film with a strong red filter over the camera lens, resulting in an overall yellow cast. A low afternoon sun, lighting the subjects from behind, increased the contrast in the scene.

Simple colors and broken-up detail *(left)* create an impressionistic picture. The photographer uprated and push-processed the film to increase the grain. He then projected the transparency onto a grain-patterned screen and photographed the resulting image.

Juxtaposed images of the same girl *(right)* make her seem to be split in half. Two photographs, one of the girl diving and one of her jumping into the water, were rephotographed with the lower part masked off. The second image was then turned upside down and the two carefully positioned together; then the composite was photographed.

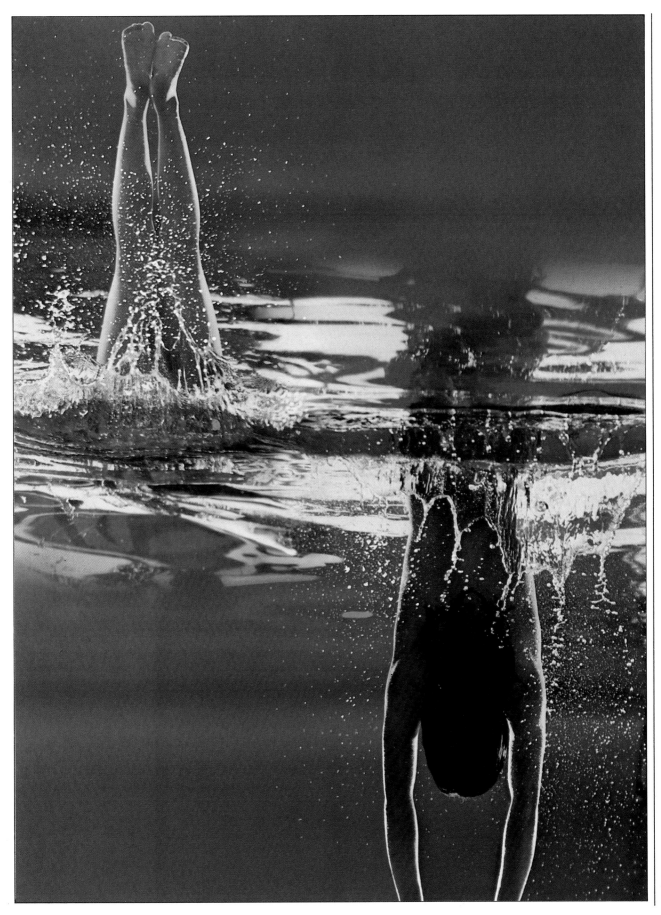

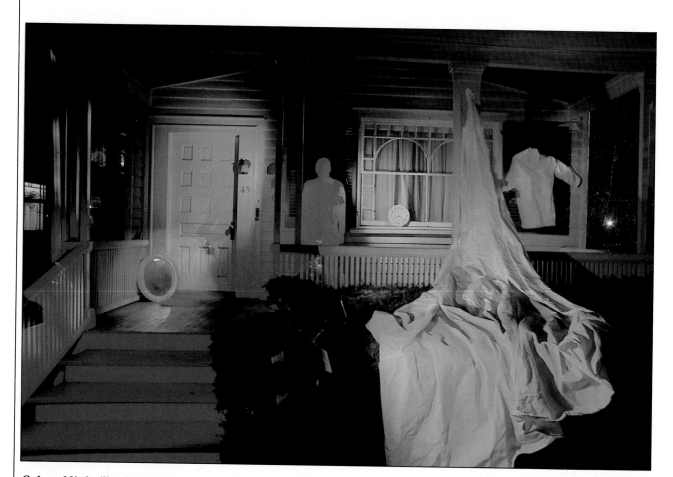

Colored light *illuminates eerie shapes in a fantasy image. The setting was an ordinary house porch at night; the strange objects are carefully placed props – cardboard shapes, sheets and a white shirt. The photographer moved around with a flash to make a series of exposures on one frame. For each exposure, he covered the flash with a different colored piece of cellophane.*

A gymnast *(right) appears to move through the steps of her routine. The effect of flowing movement created by the overlapping images was obtained very simply, using a cardboard mask with a strip cut out of it. The photographer made a number of consecutive exposures on one frame with the mask held over the camera lens, lowering the cardboard to expose a narrow strip of the frame each time.*

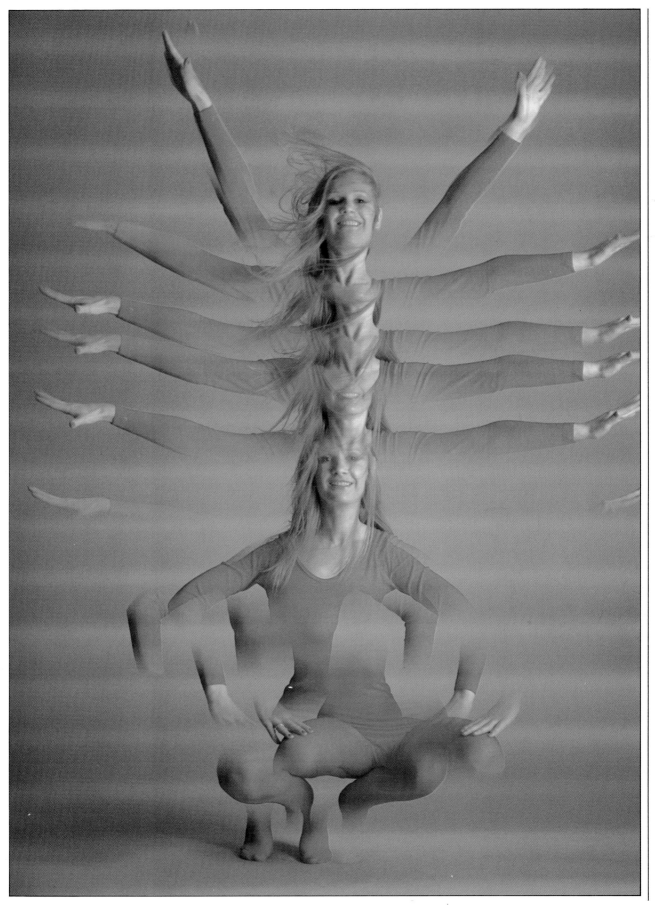

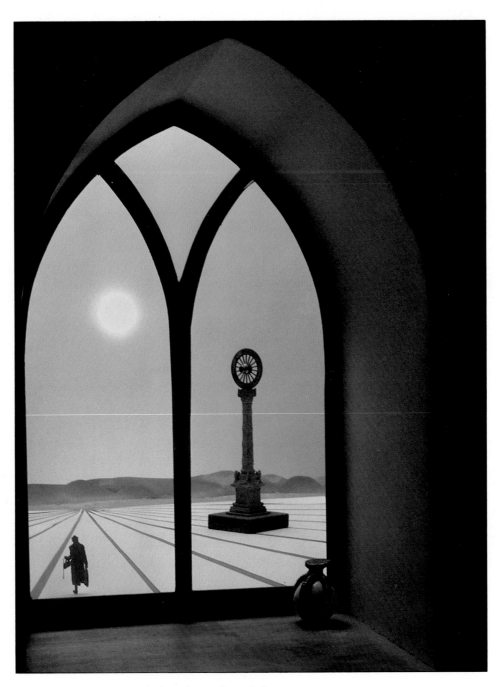

A view through a window seems
to lead the eye into infinite distance.
This convincing image is actually the
product of cleverly set-up props, with
each element helping to foster the
illusions of scale and depth. The window
arch is made of paper, the human figure
is a cardboard cutout and the converging
lines are tapered strips of paper, glued
together to lead to a vanishing point.

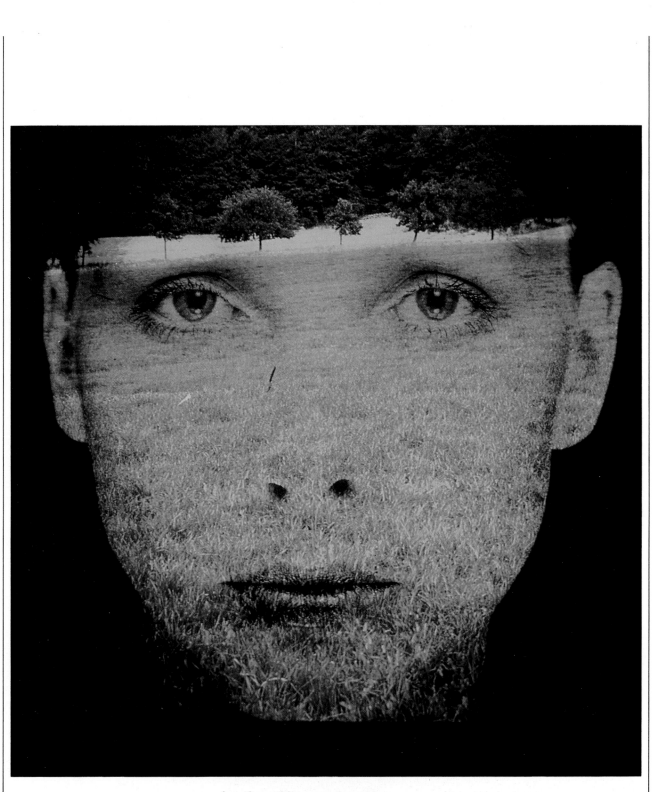

An ethereal face *superimposed on a landscape combines color, texture and detail. The photographer posed the face against a dark background and deliberately overexposed by one stop to obtain a very pale slide. He then "sandwiched" the face and the landscape into a single mount, projected the double slide onto a screen, and photographed it to make a haunting image.*

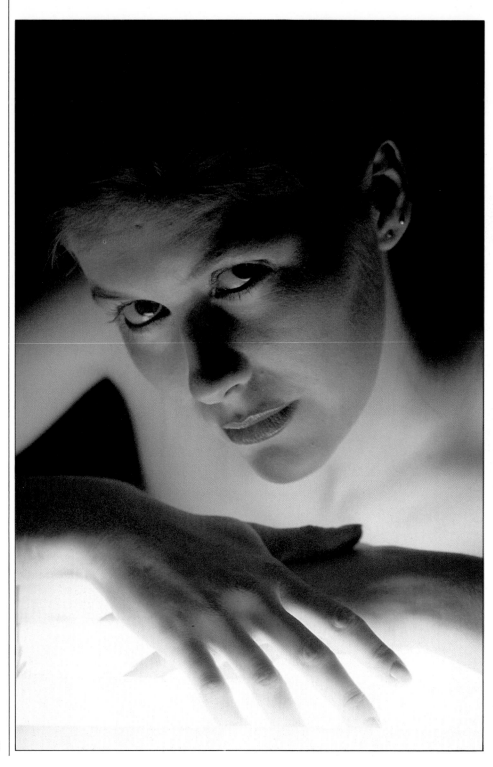

Unearthly blue light and
deep shadows (left) impart a
macabre air to a portrait.
The photograph was taken on
tungsten-balanced film, with
the subject lit from below
by fluorescent tube lighting.
The closeness of the light
source washed out part of
the image, imparting a
sense of the supernatural.

A silhouetted profile
(right) blends naturally into
a starlit seascape. Four
elements in combination make
up the image. To obtain the
silhouette, the photographer
posed the woman against a
white background, lit only
the background and used a
blue filter over the lens.
Tiny holes pierced in black
cardboard produced an image
of twinkling stars. After
sandwiching this with the
silhouette, the photographer
copied the sandwich onto a
sheet of film masked off at the
bottom. With the top masked
in turn, a second exposure
recorded the sea. Finally,
the photographer copied a
slide of the moon onto the
same piece of film, exposing
the sky area alone.

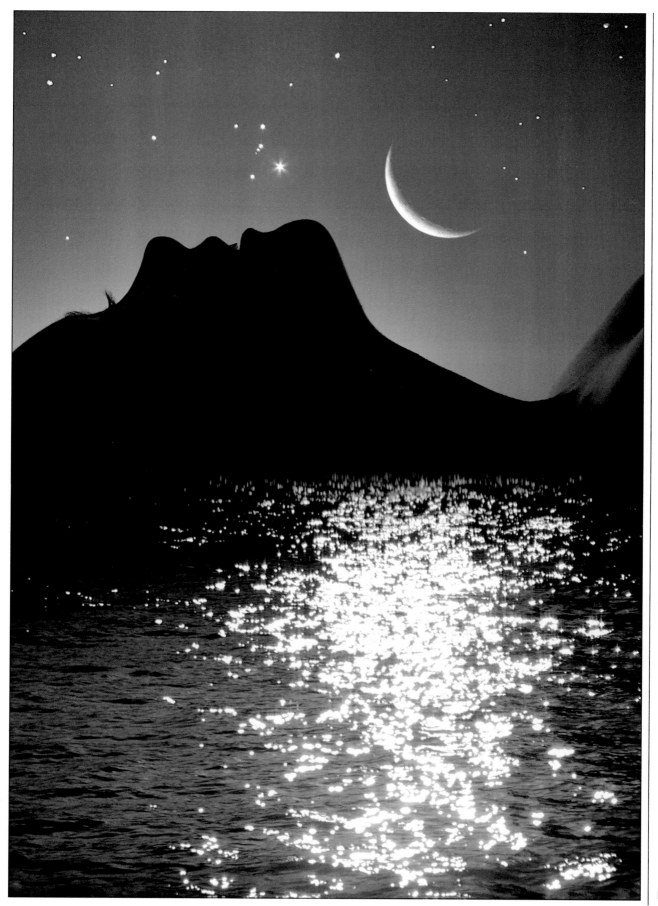

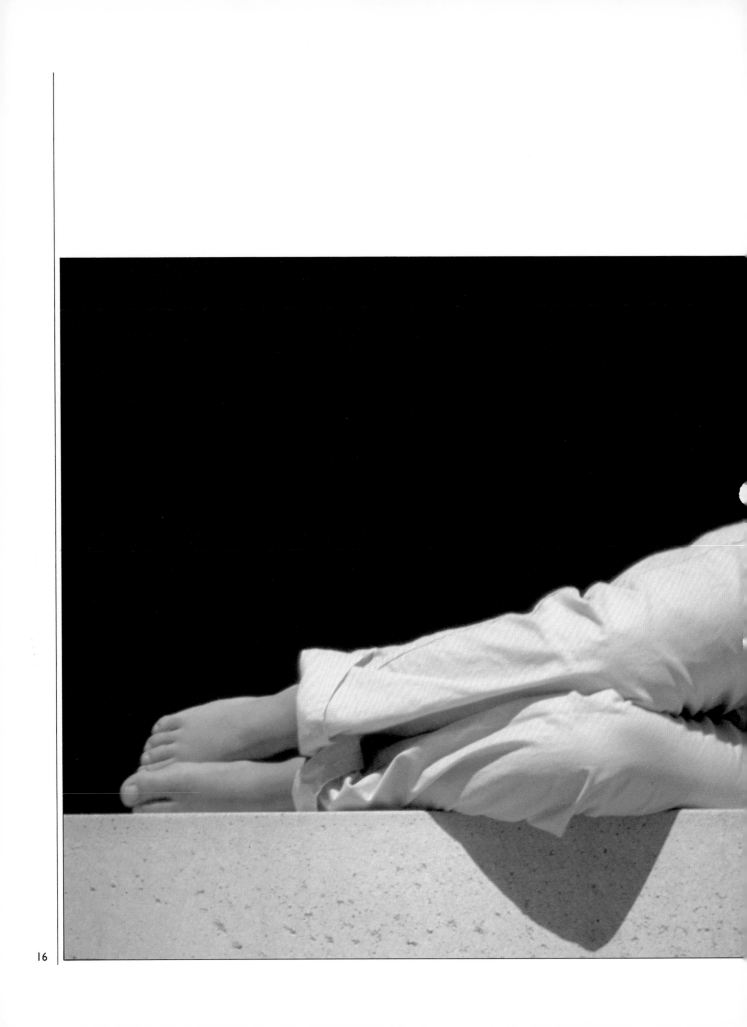

IDEAS AND ILLUSIONS

Photographic illusions result when visual preconceptions are upset. Just as conjurers employ sleight of hand to persuade us that magic is taking place, so photographers can use visual trickery to disconcert the viewer. One point to remember with this kind of photography is that you do not have to alter normality very much to create strange and baffling effects. Indeed, one small bizarre element in an otherwise ordinary image usually works better than a battery of special effects. For the picture at left, no special technique was involved – just the old theatrical trick of putting dark clothing against a dark background to make part of the body seem to vanish.

This section shows that such simple yet ingenious ideas can produce amusing, startling and beautiful pictures. Odd juxtapositions and angles, camera and subject movement, double or multiple images, tricks with color and light, the use of reflections – all these depend less on complex techniques or expensive equipment than on your own judgment and imagination.

Legs apparently severed from a torso recline casually on a wall. The wry illusion was simple to achieve: the photographer took a reflected light reading from the white wall so that all areas in shadow – including the girl's dark-clad torso curled behind the paper cup – recorded as solid black.

Juxtapositions/1

A simple but effective way to create a photographic illusion is to set up a startling juxtaposition by carefully composing the elements of a scene. Often, you can produce a bizarre picture by framing it so as to remove clues to the context of a scene and suggest an illusory relationship between foreground and background. For example, in the picture below the lightbulb seems to hang impossibly from the sky. Cropping out the context can likewise remove any yardstick by which a viewer can judge scale or depth – an effect exploited in the photograph at the top of the opposite page, in which an ice-cream cone looms like a giant monument.

Alignment of one element in a scene with another, so that the two elements seem to merge, is another way to make an intriguing juxtaposition. This approach is particularly fruitful when used to create composite people or animals, especially if you use a telephoto lens to even out apparent differences in scale. The picture on the opposite page, below, which at first glance seems to depict a person with a monstrous head, is a variation on this approach.

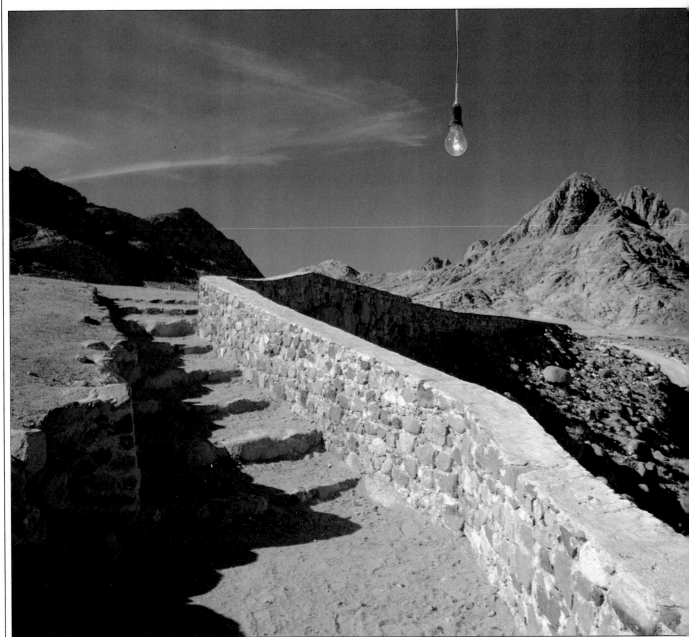

An ice-cream cone (right), lifted against the sky, resembles a huge torch with a cool white flame. To give the required depth of field and exaggerate the cone's scale, the photographer used a 28mm lens from his low camera angle.

A lightbulb (below) hangs above a sun-baked landscape. This surreal effect required no props; the bare bulb dangled from a pole projecting from a porch where the photographer stood.

A hybrid creature (below), half human, half machine, results from a simple juxtaposition – a woman in a plaid pantsuit looking through coin-operated binoculars from a panoramic vantage point. Noticing the machine's resemblance to a human face, the photographer closed in with a 200mm lens to create this witty image.

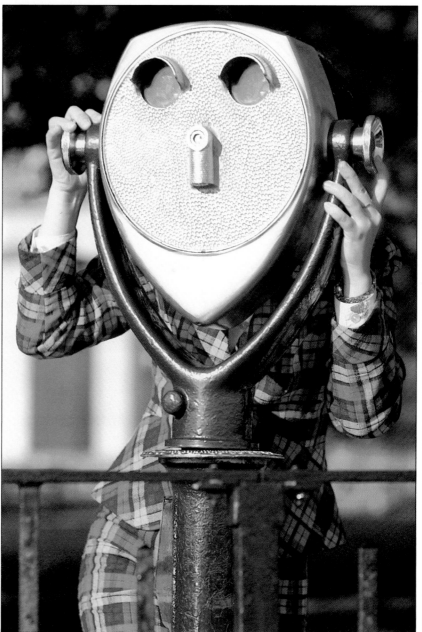

Juxtapositions/2

A man in shorts (below) *seems to walk nonchalantly along a line of car roofs against an ocean backdrop. The illusion depended on a camera angle that obscured a low wall behind the parking lot.*

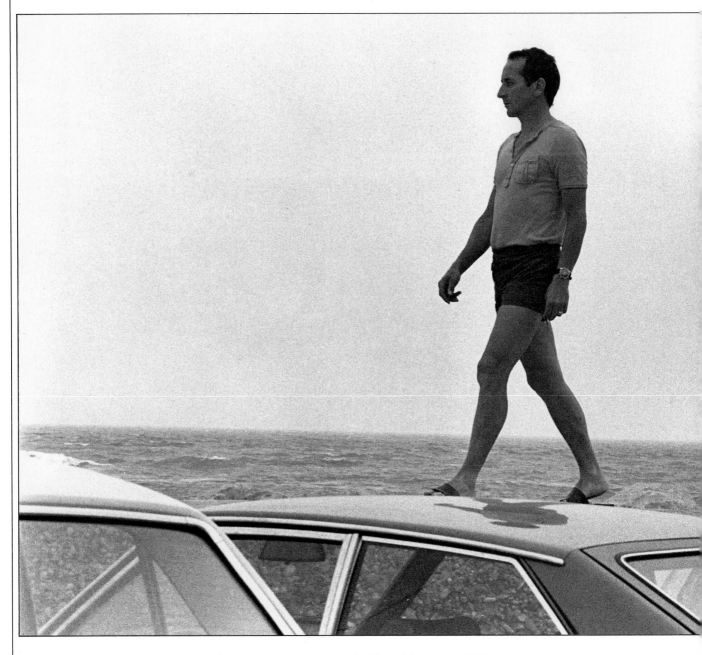

If you keep a vigilant eye open for juxtapositions, you can often produce amusing pictures that conjure up a world where the conventions of rational behavior or even the laws of physics or anatomy are suspended. The three photographs here, by New York-based photographer Elliott Erwitt, exploit this approach with a gentle sense of humor.

From the photographer's point of view, finding comic juxtapositions can be rather like seeking animals in the wild – you can spend many watchful hours with a camera before you come across a suitable subject. In addition to patience, other prime requirements are the ability to anticipate situations, to set the camera controls quickly and to press the shutter release at just the right moment. Composition is important, too: all three pictures here gain in impact from strong, simple framing, uncluttered by distracting detail.

Juxtapositions involving people generally offer the best opportunities for humor. However, you can also create clever contrasts with inanimate elements, as shown by the picture at top right.

A road sign (right) in Japan invites an improbable ascent of snow-mantled Mount Fuji. The photographer framed the mountain and sign with perfect symmetry to create an image that is powerfully graphic as well as preposterous.

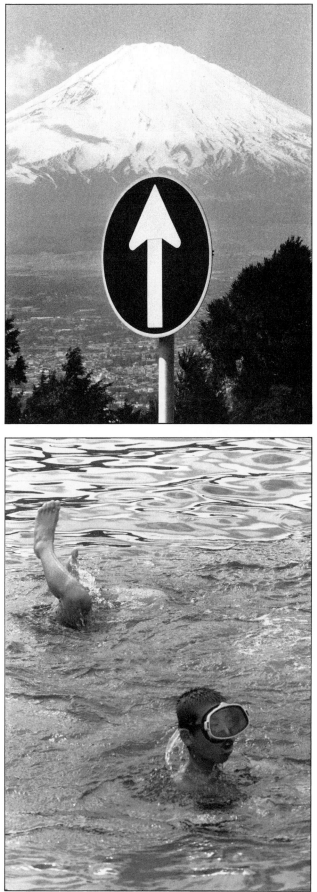

A Japanese swimmer (right) appears to have an unnaturally elongated and serpentine body, his legs splashing out of the water at an impossible angle. The legs actually belong to another swimmer in the act of diving.

Unexpected angles

Cups of Turkish coffee on a red cloth make a harmonious composition of shapes and colors. The photographer used a normal lens and took the picture from directly above. Soft shadows add tonal interest to the plain background.

Often, by finding an unusual camera position and viewpoint, you can turn ordinary subjects into intriguing images. When we look at something from an odd angle, we mentally correct distortions of perspective or scale. The camera cannot make such corrections, and by photographing from extreme angles you can exploit this limitation creatively.

As a simple example, pointing the camera directly down at a subject flattens the image: everything appears to lie on the same plane, so that forms are reduced to simple shapes. If you select a subject with strong shapes or lines against a plain, contrasting backgound, you can create almost abstract pictures such as the one at near right. The opposite technique, of pointing the camera straight up, can produce puzzling, ambiguous images in which the normal positions and relationships of objects are upset. The photograph of washing, below, is an example. With a very low viewpoint, you can also achieve distortions of scale and depth. If you use a wide-angle lens, the effect is exaggerated so that the nearer part of the scene appears unnaturally large, while the extended depth of field keeps the background sharp as in the two pictures opposite.

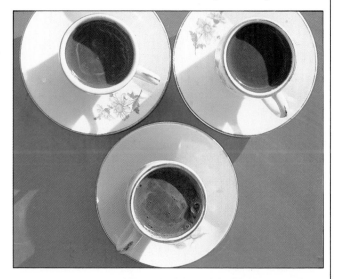

Household washing hung out to dry on clothes lines several floors up is buffeted by the wind into strange forms. Pointing the camera straight up took the subject out of its everyday context and gave the image strong background contrast.

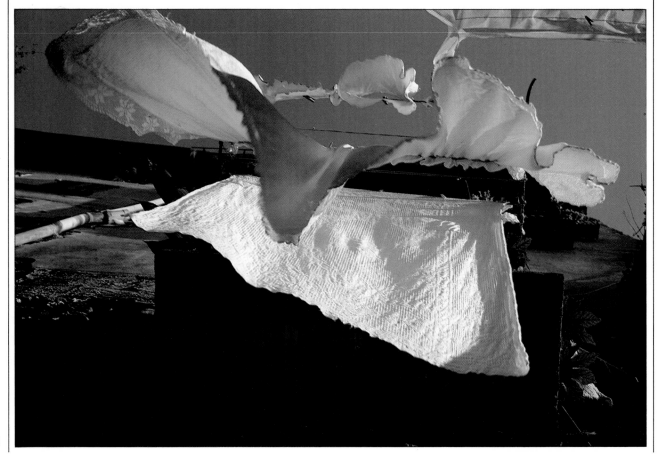

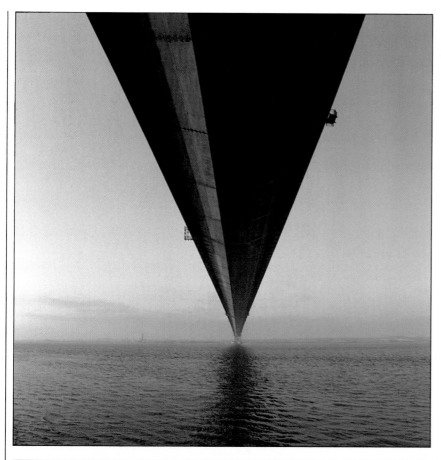

The converging lines of a bridge suggest a giant kite balanced on the far horizon. From a camera position beneath the bridge, the photographer used a 24mm lens to exaggerate perspective and thus create a sense of extreme distance.

Giant pigeons point menacing beaks at the camera. The photographer lay down, resting the camera on the ground, and used a wide-angle lens in close-up. Seed scattered to attract the birds was cropped out to strengthen the effect.

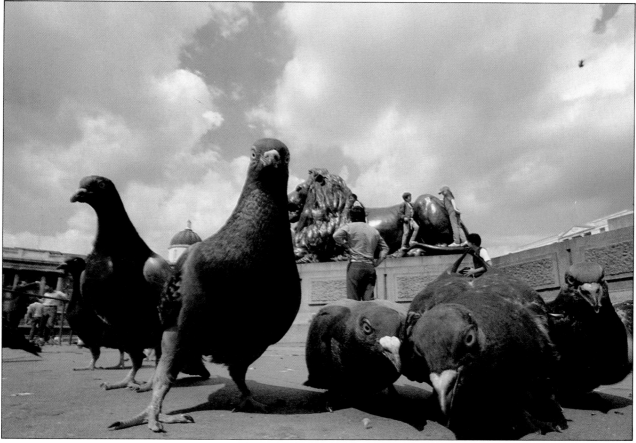

Reflections

Reflections – in mirrors, water, wet streets or any shiny surface – are an excellent source of varied and original images. However, only a perfectly smooth surface will give a true reversed image, like that in a mirror. And wet surfaces only produce distinct reflections if they are dark-toned.

The gleaming chrome of an automobile or motorcycle will give strong, clear reflections, as will well-polished paintwork, particularly when it is a dark color. And the curved surfaces produce interesting distortions, which can be similar to those obtained with an ultra wide-angle lens. For example, in the picture below, the exaggerated shape of an auto reflected in a bumper effectively conveys an impression of streamlined sportiness.

Water reflections produce highly varied effects, from the mirror image in a still lake to the strange patterns of the composition opposite, below left. To make the most of such effects, the reflecting surface should be shadowed, and the subject being reflected should be directly lit. Window reflections offer the possibility of superimposing one image on another; try to choose a subject in which the two images – the reflection and the scene inside the window – will blend successfully. In the large picture on the opposite page, the dark fronds add interest to the composition without obscuring the light-colored shapes of ornamental stonework behind.

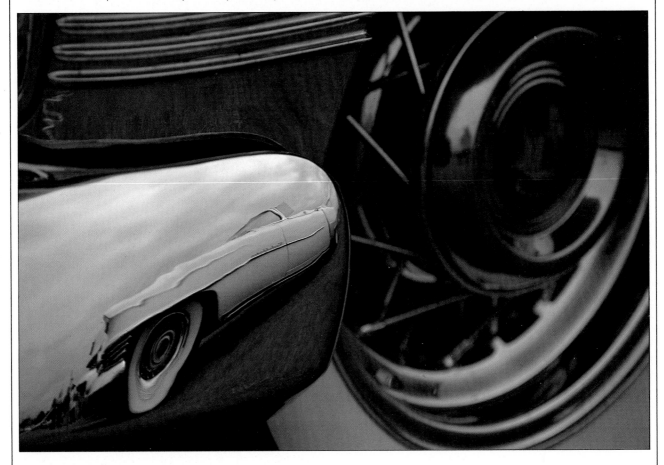

Reflections in polished chrome
produce a montage effect in this tightly cropped image, with the lines, shapes and colors of the car repeated in the distorting reflective surface of the front bumper. To prevent his own reflection from being obtrusive in the composition, the photographer used a telephoto lens and stood about 20 feet off to one side of the car.

Arcs of smudged, rainbow hues (above) mimic a colorful hang glider's birdlike movements. The photographer used reflective mylar, curled into a tube and placed over the camera lens, to give curved reflections of the subject against the glowing colors of the sunset.

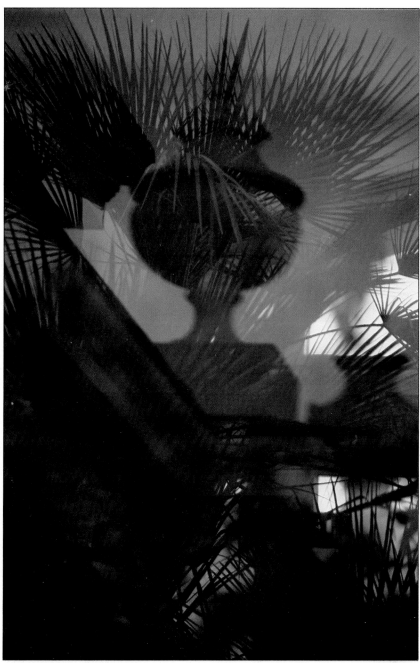

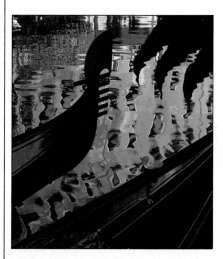

Rippled water in a Venice canal breaks up brilliant reflections, giving the impression of fragmented images scattered on the surface. The bright highlights resulted because the reflective surface was in the shade, while the reflected buildings were strongly sunlit. The dark gondolas, and the sharp detail and saturated colors of the flowers, provide an interesting contrast.

Spiky-leaved plants reflected in glass overlay the shapes of architecture viewed through the window, creating an unusual semi-abstract study of texture, tone and pattern. The photographer closed in to exclude surroundings, concentrating on the superimposed image. He used a small aperture and focused midway between the glass and the reflected image to obtain good detail in both elements.

Dramatic distortions

You can use surfaces that reflect or refract light to create unusual effects of distortion and displacement. One of the best subjects to choose for this type of optical illusion is the human face. We are so familiar with the form, shape and color of human features that any slight distortion is immediately noticeable and potentially disturbing.

An irregular reflective surface – moving water, crumpled foil, curved metal or reflective mylar –

will give varying degrees of distortion, from a slightly softened image with dissolving edges to a grotesque, nightmarish figure. Photographing through curved or textured glass is another way to achieve unusual distortions, as in the smaller picture opposite. Plain glass, if the area behind is in shadow, shows true reflections, and this realism can be used to create dramatic illusory images, as the photograph below effectively demonstrates.

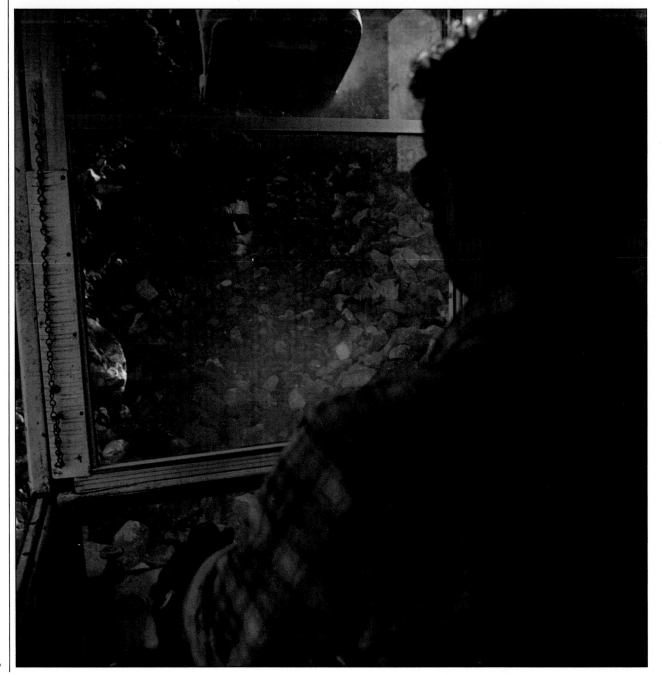

Ribbed glass breaks up the image
of a man's head behind a window into
overlapping strips, as if in a multiple
exposure. The effect is caused by light
being refracted off the uneven surface
of the glass. By closing in to exclude
the edges of the window from the frame,
the photographer focused attention on
the pattern of regular horizontal bands
that divide the image.

A beautiful face appears to slip
like a mask into the darkness. To
create this subtle distortion, the
photographer brilliantly lit the subject
against a black velvet backdrop and
photographed her reflection in a sheet
of slightly crumpled gold-colored mylar.
He used a No. 81C filter to increase the
warm tones and focused on the reflection,
not the mylar, to obtain clear detail.

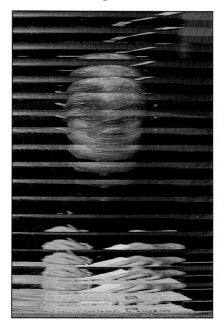

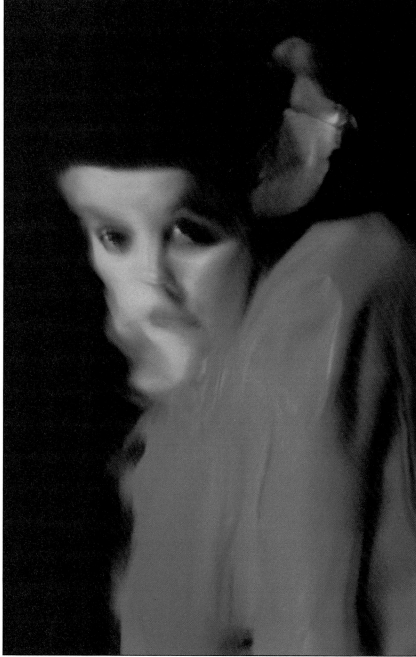

The driver of a mechanical shovel
(left) seems poised to excavate his
own head from a gravel quarry. The
curious illusion is in fact a reflection
of the man's face in the window, picked
out by a beam of sunlight. A 28mm lens
ensured that the whole scene was in focus.

Moving the camera

Camera movement during a fairly long exposure can give photographs an impressionistic, sometimes strongly abstract quality. Details are softened and distorted, colors flow into one another, and bright highlights trace gleaming patterns across the image. You can obtain a whole range of blur effects by moving a handheld camera in different ways: tilting or jiggling it, swinging it up or down, or rotating it about the lens axis. The effect is best if the subject has inherently strong colors and patterns, as in the image on the opposite page. For a more controlled result, you can set the camera on a tripod and rotate or tilt the head during exposure. Another possibility is to take pictures from moving vehicles, so that a static scene produces streaks flowing across the frame; the picture at right is an example.

Because of the need for long exposures, you should compensate with slow film and a small aperture setting. In daylight, you may need to use a neutral density filter to further reduce the light. Rehearse the movement you plan to use before making an exposure, so that you can work out the degree of motion necessary and thus the exposure time. However, results are never predictable, and you should experiment with different exposure times to be sure of getting the effect you want.

Soft, neutral streaks (above) make an abstract image. The photograph was taken from a moving car on a highway, at an exposure of 1/2 second; the white crash barrier added contrast.

New York lights form brilliant trails shooting skyward. The photographer mounted a zoom lens on a tripod and swung the tripod head down while zooming slightly during an exposure of one second.

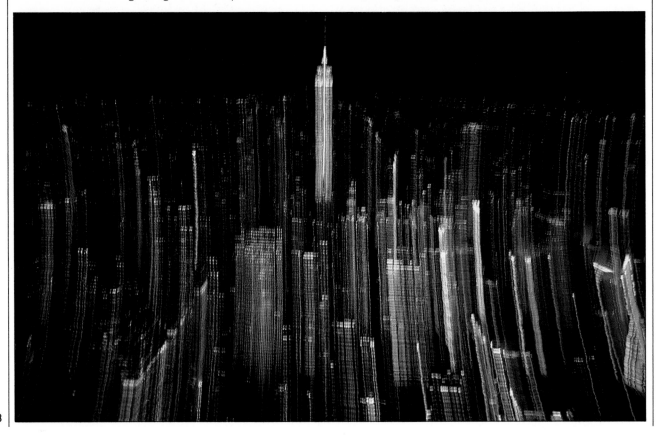

Guardsmen on parade create a
bold pattern of vibrant color. A handheld
camera was swung downward during an
exposure of 1/4 second to produce the soft
blurs and arcing highlights that convey such
a convincing sense of ordered movement.

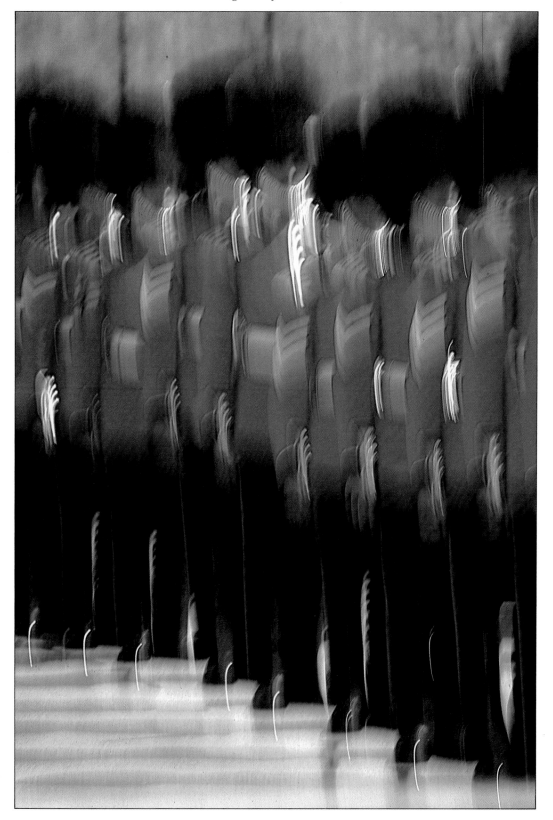

Tricks with a slow shutter

The deliberate choice of a shutter speed that is too slow to stop a subject's movement can produce exciting and original pictures. Depending on the direction and speed of the subject, you can convey movement with slight blurring while still recording a recognizable image, as in the photograph of the flag below. Or you can create strange effects such as those in the picture on the opposite page, below, in which the central part of the image has dissolved into a formless blur.

To stop camera shake during slow shutter-speed exposures, you usually need to use a tripod. If you are photographing in daylight or bright light, you may also need to put a neutral density filter over your lens to compensate for the slower shutter

speed: a 0.9 filter, for example, reduces the light reaching the film by three stops. Neutral density filters also enable you to set a wider aperture for shallow depth of field, so that you can throw a distracting background out of focus.

You can obtain beautiful abstract images by using a very slow shutter, of several seconds or more, for dusk scenes with colored lights. During lengthy exposures, even slight movement of the subject will cause highlights to spread into shadow areas and colors to flow. In the lower picture opposite, the effect was exaggerated by shining a colored light onto the subject. The reinforced glass of the balcony diffused the hues of the street lights below, adding texture to the composition.

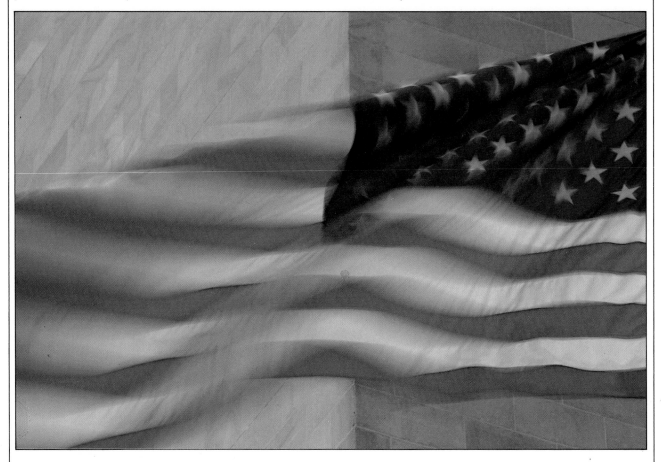

A flag fluttering in the breeze appears as soft ripples of color at a slow shutter speed of 1/8 second. The photographer carefully framed the composition to include the tones and lines of the wall behind, which echo those of the flag.

***Whirling chairs** at a fairground dissolve into smoky shapes resembling the dark clouds behind them. A 1/4 second exposure also streaked the lights but recorded the rest of the scene sharply.*

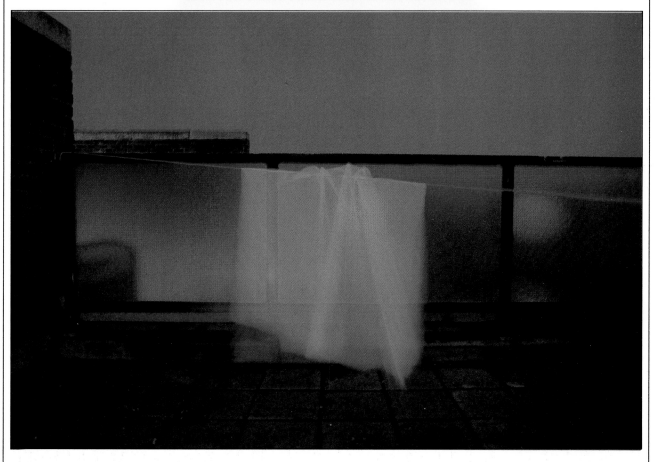

*A **wind-blown sheet** on a line glows with vivid, fluorescent color against a cool twilight setting. The photographer shined a red lamp on the sheet and set a five-second exposure to get the diaphanous effect against the soft background hues.*

31

Tricks with focus

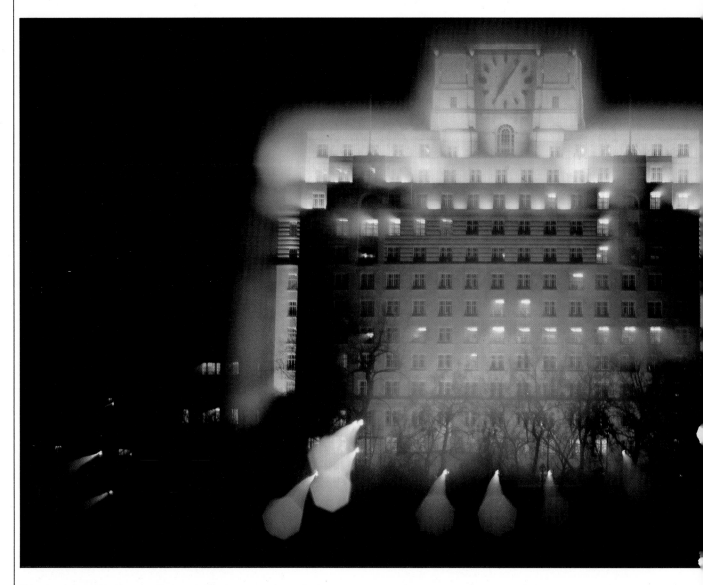

Blurred focus is generally regarded as a serious fault in photographs. However, if you deliberately defocus the picture, and carefully control the degree of softness, you can sometimes create unusual images that succeed precisely because they break with this convention.

The effect of defocusing depends on the focal length of the lens that you use, the aperture, and the subject matter. In general, the subjects that work best are ones with strong colors or those that form bold, recognizable outlines against contrasting backgrounds, as does the fisherman in the picture at right. Detailed, complicated subjects tend to make confusing images when they are photographed out of focus.

Avoid using wide-angle lenses, because even at full

aperture they record most of the picture sharply. Telephoto lenses are much more suitable; they give you the ability to regulate sharpness with both the focusing ring and the aperture setting. Use the camera's depth of field preview button, if it has one, to check how these two controls affect the appearance of the picture.

If you set an exposure of several seconds, you can shift focus while the shutter is open to produce images that are only partly blurred, as shown above. Use a tripod to keep the camera steady during exposure, and focus the picture sharply before opening the shutter. Once you have started to expose the film, you can gradually turn the focusing ring to soften the subject's outlines and surround it with radiating lines of color.

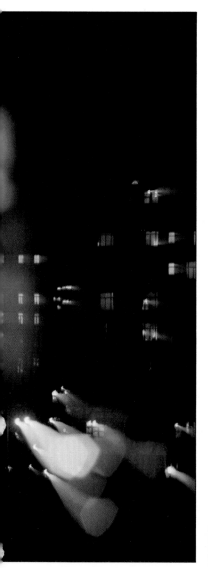

A floodlit building
(above), *defocused during a
10-second exposure, seems
to glow with energy. To keep
some details sharp, the
photographer waited three
seconds before starting to
turn the focusing ring.*

Rings of light (right)
*break up a fisherman's
outline. A defocused mirror
lens created the circles
from brilliant highlights
in the sunlit water.*

Tricks with flash

An electronic flash unit is such a familiar piece of equipment that you can easily overlook its potential for special effects. Yet with a little ingenuity you can turn a regular flash photograph into an exciting and unusual image – as these pictures show.

The easiest way to do this is to take pictures in dim light at a slow shutter speed. Your camera may have an X or a lightning bolt symbol on the shutter speed dial to indicate the limit of flash synchronization; this is simply the maximum speed, and the flash will operate equally well at slower speeds. Choose a speed between 1/15 and one full second, then take pictures as usual. When you press the shutter release, the flash will fire but the shutter will remain open, so that the ambient light continues to form an image. If the background is lit continuously from another source, and you set a long exposure, a moving subject lit momentarily by flash will appear sharp but ghostlike, as on the opposite page, below.

Try experimenting with different shutter speeds and moving the camera to produce dynamic images such as that at right. If you have a tripod, you can get effective results by firing the flash several times on a moving subject at night, as explained opposite.

Another useful technique for flash pictures is to stretch brightly colored material over the reflector of the flash. Any translucent material will do; the photographer who took the picture on the opposite page, below, used the red cellophane wrapper from a candy bar to add brilliant color to the foreground.

A roller skater speeds backward past the camera, his motion frozen by a flash. By panning to follow the figure during the one-second exposure, the photographer spread the lights around him into brilliant streaks of color.

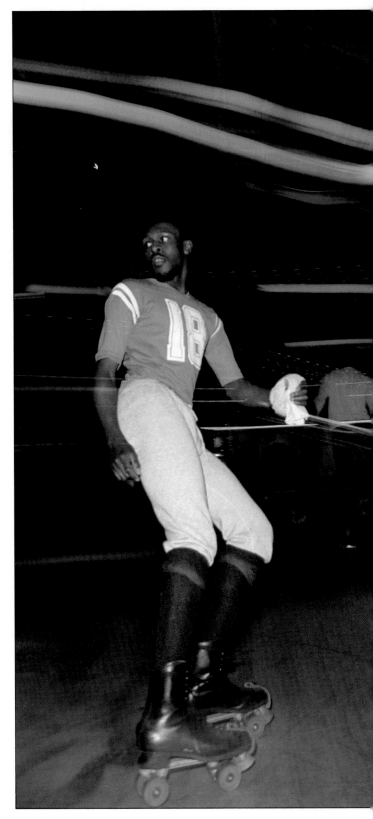

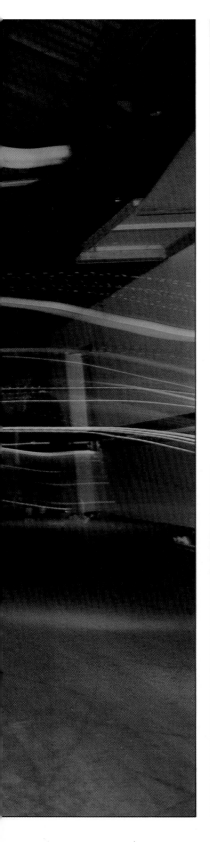

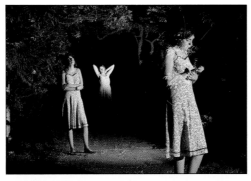

Multiple flash

In darkness, you can make several flash exposures on one frame. For multiple images of a single subject, attach the camera to a tripod, and lock the shutter open using the B setting and a lockable cable release. Then fire the flash to light the subject in several positions. For the example at left, the model moved away from the camera and the photographer followed her, firing a flash at each of three locations, as diagrammed below.

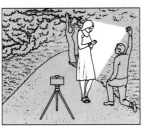
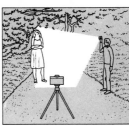
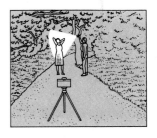

A splash of red from a filtered flash breaks the monotony of blank gray city slabs. A passer-by, frozen in motion by the flash, looks like an apparition, because the floodlit wall behind her formed an image on film during the 15-second exposure.

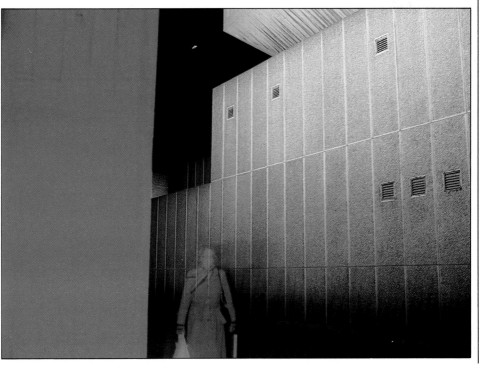

Seeing double

You can produce intriguing double images if you expose the same frame twice and use a simple masking procedure. By masking off one side of the lens when you make the first exposure, you form an image on just one side of the frame. Then, for the second exposure, you move the mask so that it obscures the opposite side of the lens. If the subject remains the same between the two exposures, your picture will look perfectly normal; but if you make changes – for example, by including the same figure on each side of the picture, as shown opposite – you can create incongruous and surprising effects.

The procedure is simplest if your camera has a double-exposure lever. This control enables you to cock the shutter for a second exposure without advancing the film. If your camera does not have this feature, you can still make a double exposure using the method diagrammed below.

Before you take the final picture for real, you should run a test to evaluate the correct size of mask. If the mask covers too much of the lens, your picture will have a black line across the middle. If the mask is too small, a white line (caused by overexposure) will divide the frame. The correct width

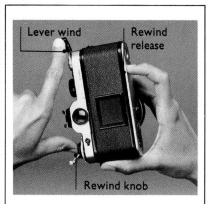

Making a double exposure
Most cameras have a double-exposure-prevention device, and only a few have a control to override it. However, you can make a double exposure on any 35mm camera, as follows. First, take up any slack in the film by winding the rewind knob. When the film is tight, press in the rewind release (usually on the camera's baseplate). This frees the sprocket wheels that usually advance the film between exposures. Finally, advance the lever wind without letting go of either the rewind knob or the rewind release. This procedure will cock the shutter for a second exposure without advancing the film.

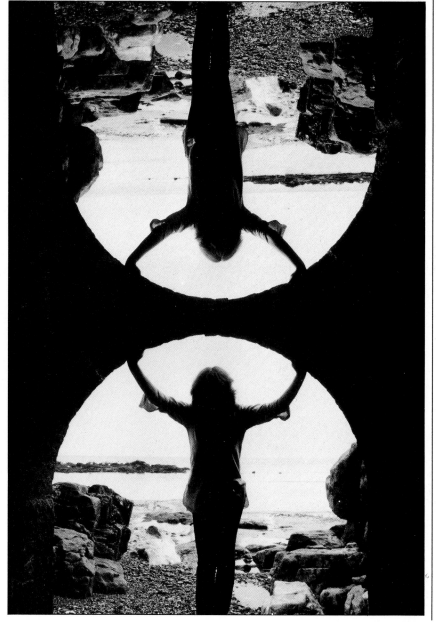

A stone bridge and a figure beneath form a bold double-silhouette. Inverting the camera and moving the lens mask between exposures put the same image on both halves of the picture. Deliberate underexposure hid the overlapping areas.

may not be exactly half the diameter of the lens; it will depend on the focal length of the lens and the aperture. Thus, when taking the test pictures, use just one lens and keep the aperture constant while you try several widths of mask. Start with three masks, as explained below.

Even if you are completely successful in positioning the mask, there is likely to be a slight overlap between the two frame halves, as in the picture below. To disguise this, keep important parts of the picture well away from the middle of the frame, or choose a subject that conceals the overlap.

A street musician gains an identical twin with the aid of the camera. To ensure that the two half-images joined as accurately as possible, the photographer locked the camera to a heavy tripod and took care not to move either the camera or the tripod between exposures.

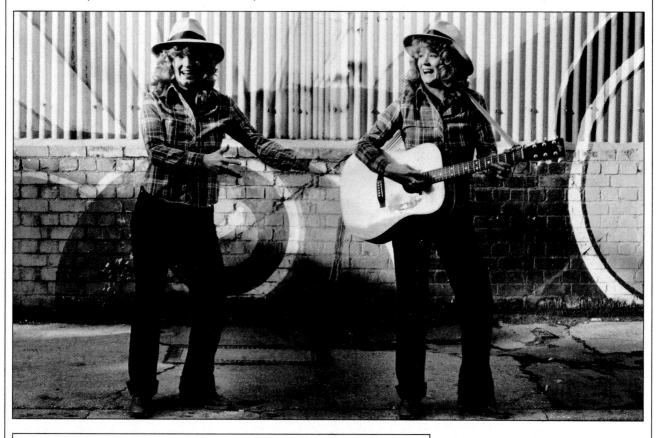

Making and using a lens mask
From black cardboard, cut half circles, each the diameter of your lens filter thread. Make three masks – one to cover precisely half the lens, one $\frac{1}{16}$ inch ($1\frac{1}{2}$mm) wider, and one $\frac{1}{16}$ inch narrower – and use the one that works best. To use a mask, tape it onto a clear filter and screw this onto the lens. After the first exposure, unscrew the filter half a turn so that the mask now covers the other half of the picture.

Ghosted images

Superimposing images on a frame by exposing the whole frame twice to different subjects can produce fascinating results. To do this, you can cock the shutter for a series of exposures without advancing the film, as already described; this technique produced the picture below at right. An alternative method, explained in the sequence opposite, is to run the same film through the camera twice to give an entire roll of double images. With this method, it is important to align the film so that the frames match up for the second set of exposures. To help you combine the images successfully, make sketches of the first set of subjects, so that you can see how they occupy the frame when you come to expose the film again.

For best results, choose your subjects carefully so that details in the overlapping images do not cancel one another out. If one subject has a dark background, details of the other subject will show through clearly. If there is substantial overlap of light or medium tones, you will usually need to reduce exposure time by half for each of the two exposures to get a correctly-exposed final image. Sometimes, however, you can use a meter-read exposure for one image to enhance a surreal effect, as in the picture opposite, below.

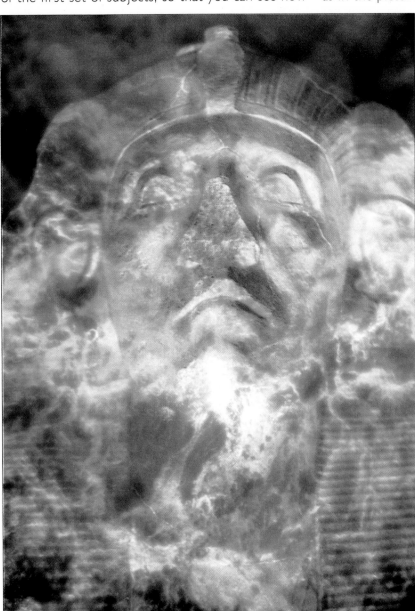

A lace curtain (left) combined with a sphinx head creates an eerie image. The photographer used tungsten film and underexposed each subject by one stop.

A flotilla of swans (below) drifts under an overcast sky. The scene was recorded twice on one frame, but between the exposures the lens was changed from a 90mm to a 35mm and the camera was angled to shift the horizon.

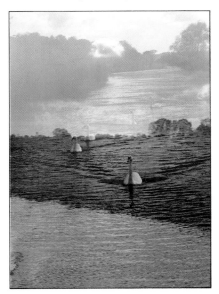

A ghostly face (right) rises out of a wintry landscape. The photographer gave full exposure to the landscape to increase the misty, dreamlike effect.

Exposing film twice

1 – Load the film in the normal way, moving the advance lever until both the perforated edges of the film are engaged with the sprocket wheels on the spool.

2 – Check that the shutter is tensioned to ensure evenly spaced framing. If you do not do this, you will be unable to align the frames for the second exposures.

3 – With a small, sharp knife or a pin, make a scratch alongside the sprocket wheel on each side of the film, to mark the position for the second exposures.

4 – Expose the roll of film to the first set of subjects. If a subject has light areas that will overlap the second image, halve exposure to avoid an overexposed final image.

5 – Rewind the exposed roll of film until the tension slackens. Take care that you stop winding at this point, or the film may disappear into the cassette.

6 – Cocking the shutter as before, align the scratches on the film with the sprockets. Expose the film to a new set of subjects, adjusting exposure as in step 4.

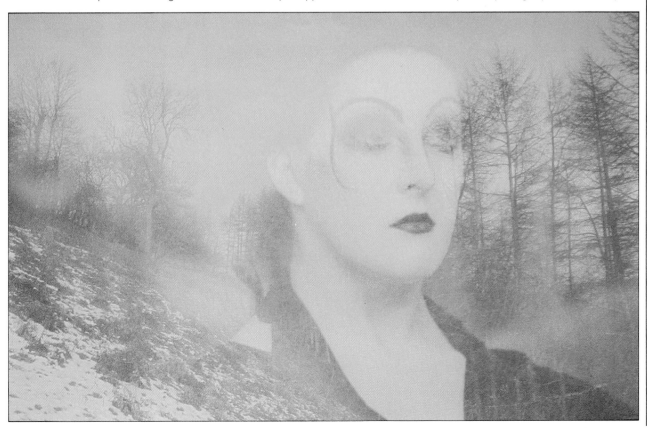

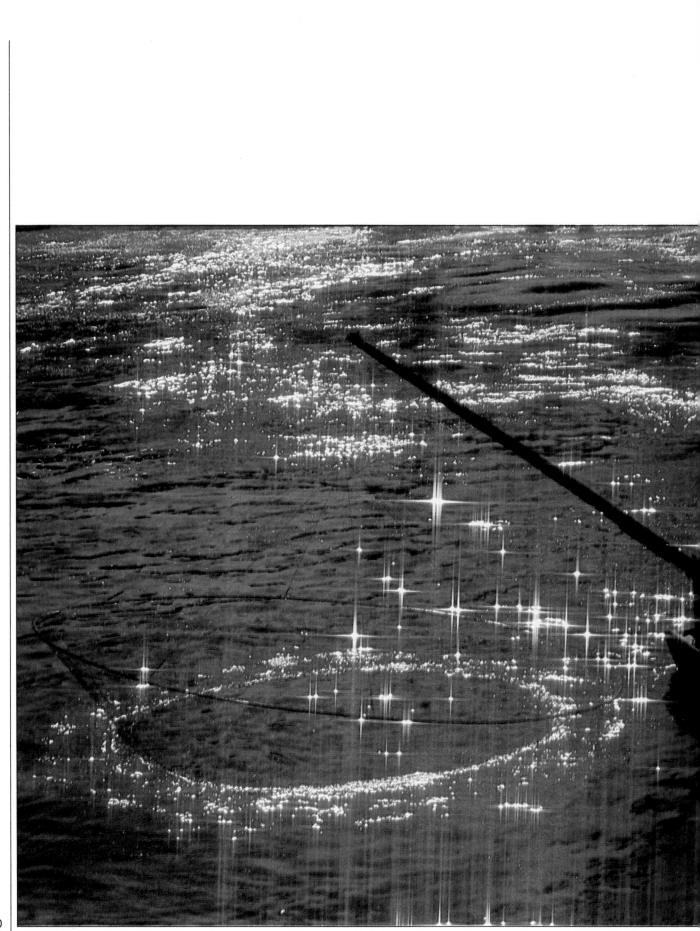

CAMERA AIDS FOR SPECIAL EFFECTS

Once you have taken your first steps into the exciting realm of special-effects photography, you will soon want to extend your scope with the help of various lenses and camera attachments. If you already have a zoom or wide-angle lens, this need not involve you in extra expense. Apart from the lens, camera and film, all you need is a willingness to break the rules of conventional picture-taking.

For an instant transformation of color or form, you can easily make your own filters or screens to fit over or place in front of the lens. But commercially available filters are also relatively inexpensive, and you may want one of these for a particular effect – for example, to add glittering highlights to a view of a lake, as in the picture at left.

Single-color, two-color and graduated filters are especially effective for controlling the appearance of a landscape, either by adding atmosphere or by dramatically altering its hues to produce a dream-like view. For stronger color changes you can use infrared film, or film balanced to a light source other than the light that falls on your subject. The section that follows shows some of the novel pictures you can take by simply experimenting with such equipment and techniques.

Two fishermen winch their net out of a lake to inspect their catch by the light of the early evening sun. A starburst filter over the lens turned the reflected highlights into a pattern of four-pointed stars.

Zooming

Moving the focal-length control of a zoom lens during a long exposure is an excellent way to suggest dynamic movement in a static scene or to increase the sense of speed in a moving subject. For even more spectacular pictures, there are several ways of varying the characteristic zooming effect of lines radiating out from the center of the image.

If you move the zoom control through its full range for as long as the shutter is open, the result can be beautiful abstract patterns, as in the image at right. By operating the zoom for only part of the exposure time, you can create effects as dramatic or subtle as you wish, while keeping the main subject relatively sharp. Another approach is to pan or tilt the camera at the same time as zooming, so that you get horizontal or vertical streaking as well as radiating lines. These types of zooming work best on scenes with specular highlights – intense reflections or bright points of light – that form distinct streaks across the image, as in the picture opposite, below.

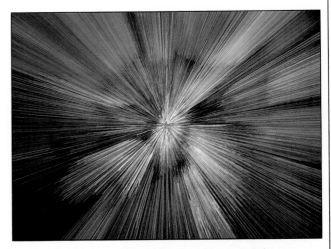

Christmas lights *explode like a firework display. The photographer centered the subject and moved the zoom through its full range during exposure.*

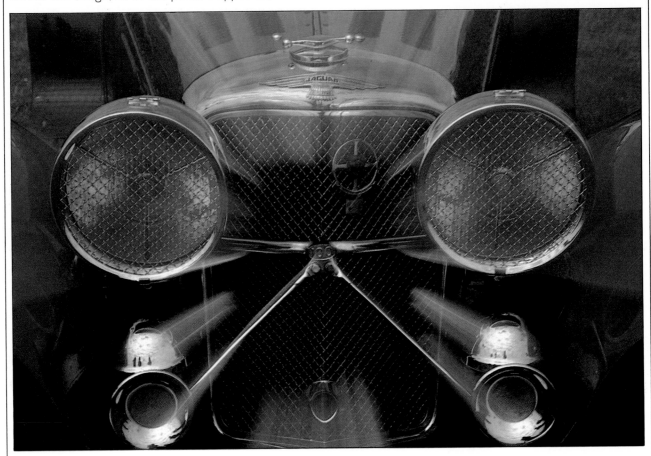

The front of a vintage car *is dramatized by careful zooming, done during the latter half of a one-second exposure to retain sharp detail.*

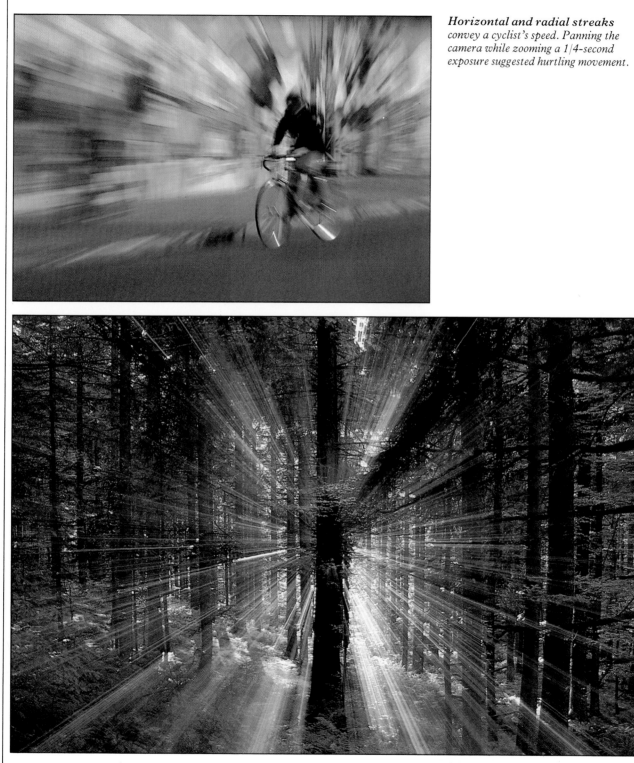

Horizontal and radial streaks *convey a cyclist's speed. Panning the camera while zooming a 1/4-second exposure suggested hurtling movement.*

Sunbeams *pierce a gloomy wood. The photographer exposed the scene for a 1/2-second, then moved the zoom control for another 1/2-second exposure.*

Lenses for distortion

Specialized applications have led manufacturers to develop lenses that distort pictures in unusual ways, and photographers have been quick to make use of these distortions for creative effect. For example, the original purpose of a fisheye lens was to photograph the sky and clouds for weather records. But fisheye lenses can produce striking or amusing images of a great range of subjects, especially those that offer sweeping perspectives.

There are two types of fisheye lenses, but they share some similar characteristics. Both take in a field of view of 180° or more, and both distort straight lines into curves. "Full-frame" fisheye lenses create images that fill a rectangular picture frame, as shown in the center example here. The other type

of fisheye creates more distortion to form a circular picture, as at top right.

Fisheye lenses do not distort all straight lines — those that pass through the center of the frame remain unchanged. With careful composition, you can use this characteristic to control and restrict the distortion in your photograph.

Anamorphic, or "scope", lenses manipulate the picture by squeezing the subject in much the same way as the curving mirrors at an amusement park. By rotating the lens, you can change the direction of distortion so that the subject seems smeared out diagonally or stretched either vertically or horizontally, as shown in the sequence of pictures reproduced below at left.

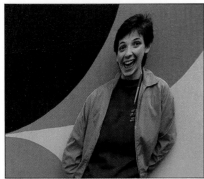

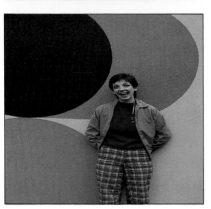

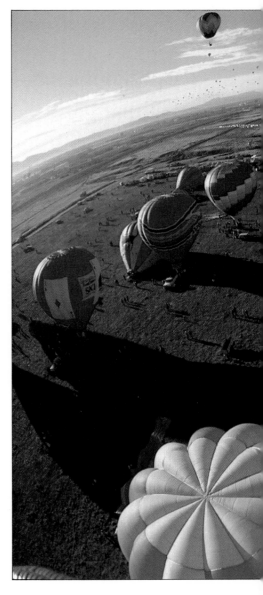

Distorted portraits
The sequence at left shows the squeezing effect of an anamorphic lens used here for humor. First developed for wide-screen movies, anamorphic lenses such as the one above contain a cylinder of glass. This squeezes a broad image into the normal film frame. When projected through a lens containing a similar cylinder, the picture expands to panoramic proportions. But without the projection lens to readjust the proportions, the subject appears squeezed in one plane.

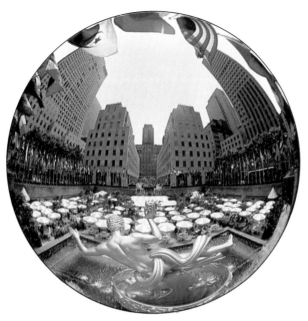

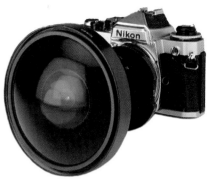

A rounded view of the Rockefeller Center encloses the plaza with waving flags and bowed buildings. An 8mm fisheye lens (above) enabled the photographer to take a fresh look at this familiar New York City scene.

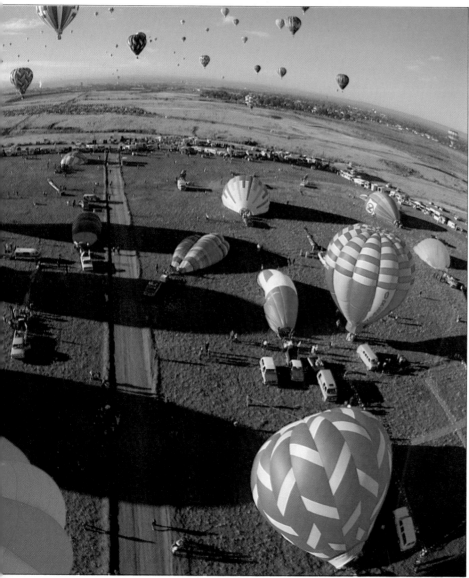

Hot-air balloons climb sedately into the sky, their rounded forms harmonizing with the curving horizon. The photographer used a 16mm full-frame fisheye lens (above) to take in the whole scene from a low-altitude balloon. By composing the picture so that a road ran through the center of the frame, he retained one straight line to contrast with the curves that dominate the rest of the picture.

Close-ups

The human eye has a limited ability to focus on nearby subjects; anything closer than about six to eight inches (15–20cm) looks blurred and indistinct. The camera has no such limitations. By moving the lens progressively farther from the film, you could theoretically focus in on subjects touching the front surface of the lens.

For special-effects photography, this facility is particularly valuable. Perhaps surprisingly, the most suitable subjects are often the most familiar; for example, common objects such as the toothbrush opposite take on a new identity when photographed from just inches away, then printed up or projected larger than life-size. Look especially for subjects that have little depth – the oily water surface at right is a good example – because depth of field is very shallow at close distances.

For occasional close-up work, extension tubes are probably the most suitable equipment. They give better quality and greater magnification than do supplementary close-up lenses, and they are much cheaper than bellows or macro lenses. Used with a normal lens, a set of extension tubes will enable you to photograph subjects at 1:1 magnification. This means that the camera's field of view will be the same size as the film – 1 × 1½ inches (24 × 36mm). A wide-angle lens placed nearer to the subject is capable of much greater magnification than a normal lens used with the same extension.

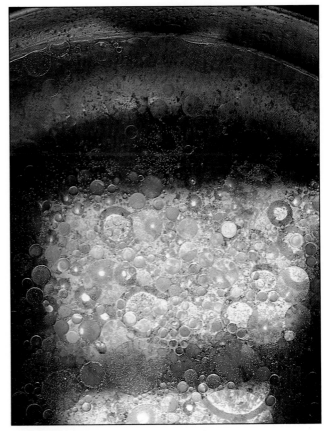

Oil on water (above) makes circles of ocher in a cooking pan. The close viewpoint excluded extraneous detail, emphasizing the pattern. Because the pan was quite large, a 50mm lens was able to focus close enough unaided – 15 inches (40cm) – to achieve tight framing.

A toothbrush and a tumbler of water (opposite) form a stylish still-life when seen from just inches away. Because the subject was transparent, lighting presented few problems: the photographer diffused the light from a window using a sheet of tracing paper, then placed the glass on the windowsill. A ½-inch (12mm) extension tube provided the necessary magnification.

A pink rose petal, frozen in ice, creates a colorful, abstract close-up. The photographer sprinkled a handful of petals into a dish of water, then left the dish in his freezer for an hour. Breaking up the ice revealed subtle hues, which he recorded with a 50mm macro lens.

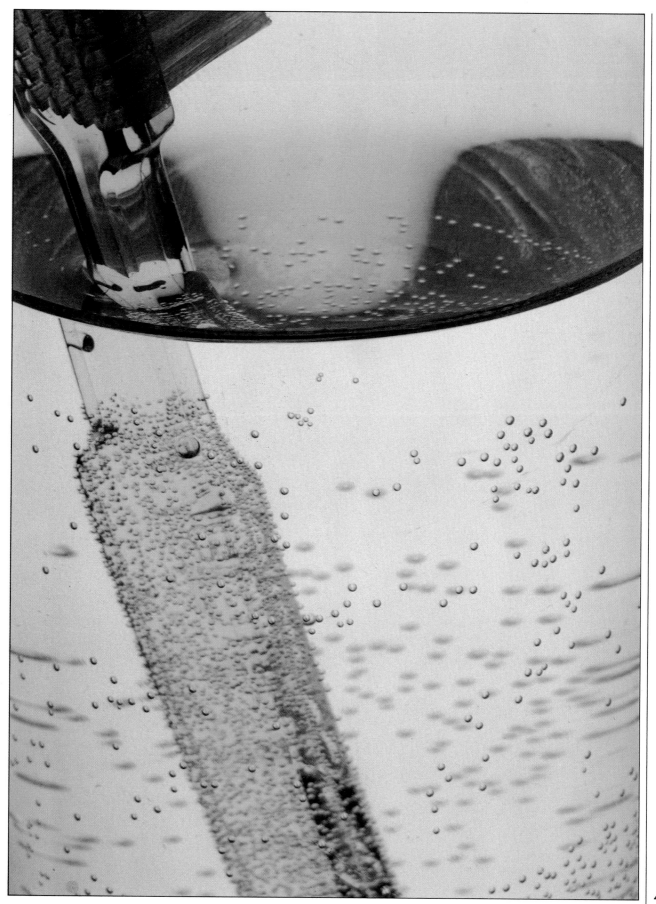

Split-field close-up lenses

When objects in the viewfinder are very near the camera, you can usually show either the objects or the background sharply, but not both. However, with a split-field close-up lens screwed onto the front of your main lens, you will be able to keep foreground subjects just inches from the camera in focus, without sacrificing sharpness in the background, as these pictures show.

Such dramatic contrasts of scale will look convincing only if you take special care with composition. As explained in the box on the opposite page, the construction of the split-field lens results in a blurred zone across the middle of the picture. On one side of this zone, nearby subjects are sharp, and on the other side distant detail is recorded clearly.

So if possible you should compose the picture with only unimportant parts of the subject in the middle third of the frame, as demonstrated by the examples on these pages.

Remember, too, that depth of field is very shallow when the subject is close to the camera; therefore, to keep all of the foreground sharp, you will have to stop down the main lens to a small aperture, as the photographer did for the picture below at left. Otherwise, confine your foreground subject to a shallow plane.

Never allow sunlight to fall directly on the split-field lens. The cut-glass edge causes light to scatter in a way that can veil your picture with flare, so use a lens hood or shade the lens with your hand.

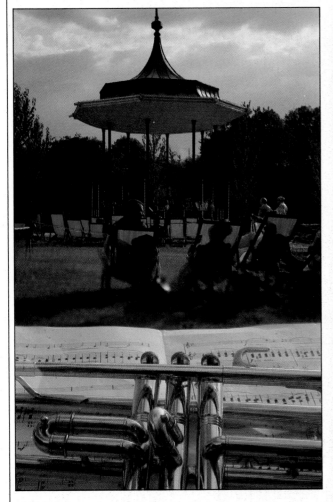

A shining trumpet and a brass band appear equally sharp, although a great distance separates them. The straight edge of the sheet of music was positioned just below the blurred central zone created by the split-field lens.

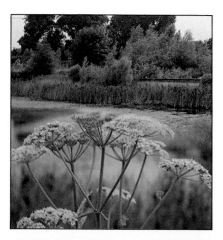

Cow parsley flowers close to the camera lift their heads against a background of distant trees and bushes. To record both the plant and a broad view of its habitat on one frame the photographer used a +1 diopter split-field close-up lens.

A red kite catches the breeze over a pebbly beach – and a split-field close-up lens brings the kite-flier's hand into focus. Here, the field is split vertically, but the blurred area of sky above the hand does not spoil the image.

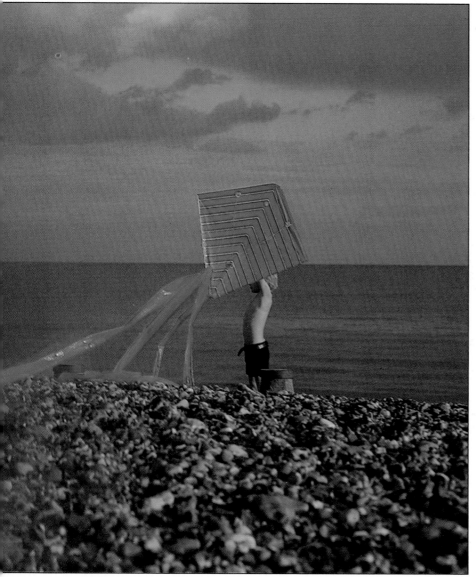

Choosing a split-field lens

A split-field close-up lens is just half of a convex lens fitted into a rotating mount, as shown above. Like that of regular close-up lenses, the power of split-field lenses is measured in diopters. If you focus your camera lens on infinity, and attach a +1 diopter split-field lens over the bottom half of the camera lens, foreground subjects 40 inches (1 meter) from the camera will be sharp, and the distant background will be unaffected. This is true regardless of the focal length of the main camera lens. With a +2 split-field lens, the foreground will be sharp 20 inches ($\frac{1}{2}$ meter) from the camera; and with a +3 lens, subjects one foot (30cm) away are sharp. The background will also be sharp, as long as the camera lens is focused correctly. Pick a split-field lens with the size of your foreground subject in mind: with a standard 50mm lens, a +1 split-field lens will fill the foreground with a subject just 27 inches (68cm) across. With a +2 and a +3, subjects 12 and 8 inches (32 and 20cm) across will fill the foreground. Wide-angle and telephoto lenses take in correspondingly broader and narrower foregrounds.

Filters for simple effects/1

By skillfully using filters to alter the color and quality of light, you can manipulate the mood of an image without making it obvious that a special effect is involved. The pictures on these pages owe their distinctive sense of atmosphere to the subtlety with which filters were used to support the compositions without intruding on them.

The ability of color to suggest mood often depends on creating an overall harmony of hues, and you can use pale color filters to achieve this – a brown filter to warm up overall tones or a blue one to give an impression of coolness. Diffusion and fog filters can evoke a dreamlike sense of the past, as in the picture opposite, below. And if you want to achieve a delicate pastel effect, you can try using a fog filter and a pale color filter in combination.

Graduated filters, with a colored half that fades gradually into a clear half, are usually chosen to add drama to landscape pictures. But these filters, too, can be used unobtrusively – as in the photograph below, in which the darkening of the sky at the upper left of the image creates the naturalistic impression of a dust cloud or heat haze over the rest of the picture. A filter holder, illustrated on the opposite page, enables you to move a graduated filter to cover the desired part of the scene. Lens focal length and aperture will affect how the boundary zone between colored and clear areas blends in. The longer the lens and the wider the aperture, the less perceptible the boundary line will be.

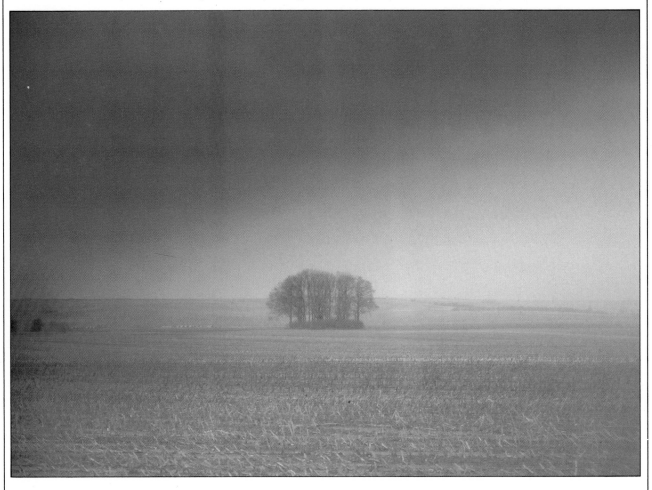

An isolated stand of trees adds interest to a study of landscape colors. A blue graduated filter darkened the sky so that a dusty haze seems to hang over the cornfield. The photographer used a wide-angle lens at a narrow aperture to make the change in tone more apparent.

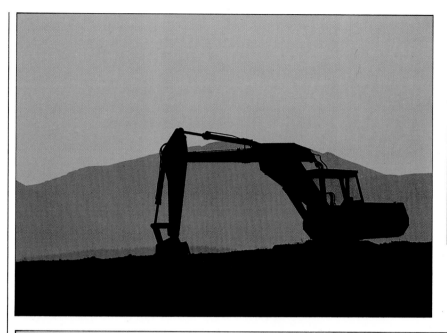

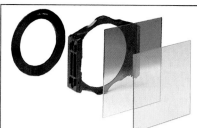

Filter systems
The system above comprises a filter holder that takes one or two square plastic filters, and an adapter ring that enables the holder to be attached to the lens. Different adapter rings are available to fit any lens size.

An earth excavator (left) makes an intriguing silhouette. The photographer used a No. 81EF brown filter to warm up the cool twilight tones and to unify the composition.

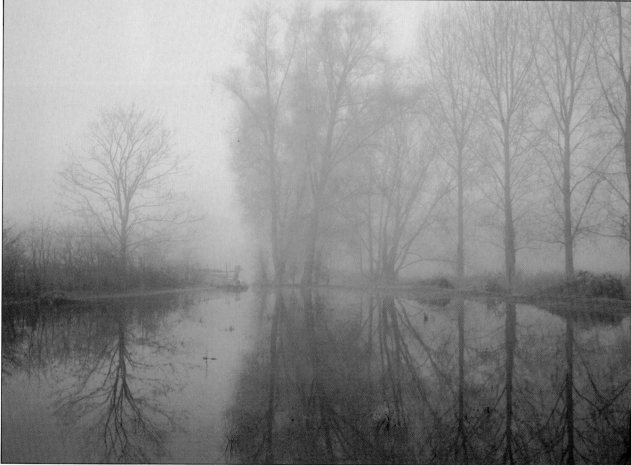

Lines of bare trees reflected in a still pond convey a mood of pastoral tranquility. The photographer used a fog filter to achieve the delicate hues and soft outlines reminiscent of early photographs, and set a small aperture to suggest mist fading into the distance.

Filters for simple effects/2

Filters that radically transform nature require a very careful choice of subject matter if pictures are to avoid looking merely gimmicky. Filters are no substitute for imagination. However, used with sensitivity and understanding, they can help create effective images such as the one below, which cleverly exploits one of the optical properties of a polarizing filter.

One very simple technique is to put a strong color filter over the lens so that a scene appears bathed in an unnatural light, as in the beach view on the opposite page. Strong red, blue or green filters can deceive your TTL meter, so take the reading without the filter in place and increase the exposure by the manufacturer's recommended "filter factor". For good results with strong color filters, simple, bold compositions are best.

Instead of adding just one color to a picture, you can produce even more unearthly effects with two colors, provided you choose an apt subject such as the grassy landscape at right. Use a two-color filter (that is, a filter with each half in a different hue) or combine two single-color filters of equal strength, oriented in opposite positions in front of the lens. Alternatively, make your own two-color filter using pieces of gelatin taped together, as diagrammed opposite. Instead of setting a wide aperture to blur the division between the hues, you may prefer to keep the aperture small to provide a sharp line that you can incorporate into the composition for creative effect, as in the skyscraper picture at the bottom of the opposite page.

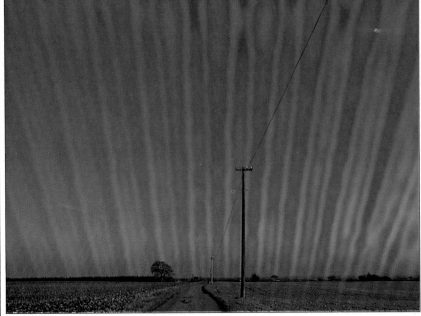

Yellow grasses (above) bend in the wind in front of a bleak background of gnarled trees. The photographer used two graduated filters, one tobacco-colored and one blue, to heighten the contrast between ripeness and aridity.

Streaks like heatwaves (left) fill a blue sky, giving the impression of an extreme weather phenomenon. For this effect, the picture was taken through a car windshield with a polarizing filter over the lens. The filter showed up light distortion caused by built-in stresses in the shatterproof glass.

The World Trade Center in New York (right) acquires new colors when viewed through a green and magenta two-color filter, which was oriented to align the sharp division between the hues with the diagonal line between the skyscrapers.

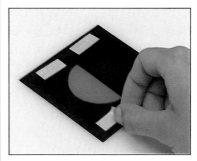

Making a two-color filter
Take a piece of cardboard and cut a circular hole in it slightly wider than the diameter of your lens. Then tape different-colored rectangles of gelatin over the hole as shown above, so that the pieces abut. You can then tape this home-made filter over your lens whenever you come across a suitable subject.

Riders on horseback (below) race along the gleaming wet sand of an empty shore, in a mystical light created by a deep blue filter. The photographer calculated an exposure increase of three stops to compensate for the blue filter's absorption of light, but set an increase of only one stop, underexposing to heighten the mood.

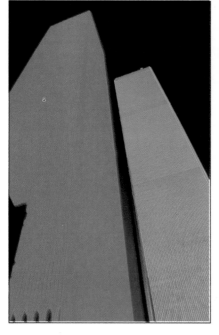

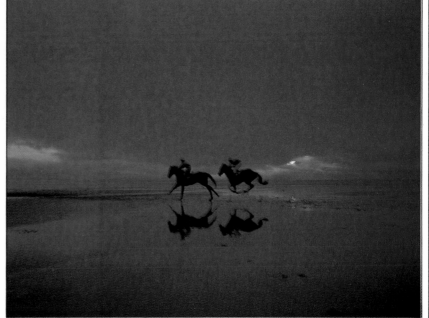

Moving color effects

Three exposures of a moving subject on the same film frame, using a filter of a different color for each, create images of beautiful, multiple hues. Each filter transmits one of the primary colors of light and blocks the two others. In stationary subjects, all of the colors of light accumulate during the exposures, so that the effect is the same as if no filters had been used. But moving subjects, because they are in a different position at each filtering stage, are separated out into images of bold color.

To make a triple exposure, use the technique described on page 36. The effect is best where moving and static elements are combined in a scene. The filters used must be of the appropriate color and density, as described below. Because you are making several exposures on one frame, and because the filters block light, you need to adjust exposure to compensate. Take a TTL reading without a filter, and for each exposure open up the aperture by one stop. Use a fast film, such as Kodacolor 400.

Rainbow colors (right) trace the movement of waves breaking on a rocky shore. A shutter speed of 1/500 for each of the three exposures separated the colors clearly. The areas with the greatest movement and the brightest highlights were recorded with the strongest colors.

Pedestrians hurrying along a city street (below) appear as transparent images of simplified color, making a pointed contrast with the gray urban setting. Mounting the camera on a tripod ensured that the static areas of the scene did not misregister during the triple exposure.

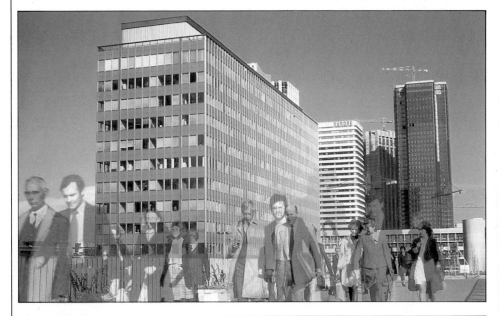

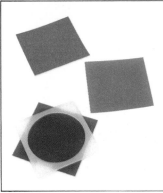

Using filters for triple exposures
Filters for color-separation effects during multiple exposures should match as closely as possible the light sensitivity of the film's three emulsion layers. They must be the primary colors red, blue and green, and of strong density, so that each one will block out most of the two other primary colors of light. Kodak Nos. 25 red, 61 green and 38A blue, shown at left, provide a reasonably balanced result. To get the best color, and to ensure that static objects appear in their natural hues, you should use color negative film and make fine adjustments to color at the printing stage.

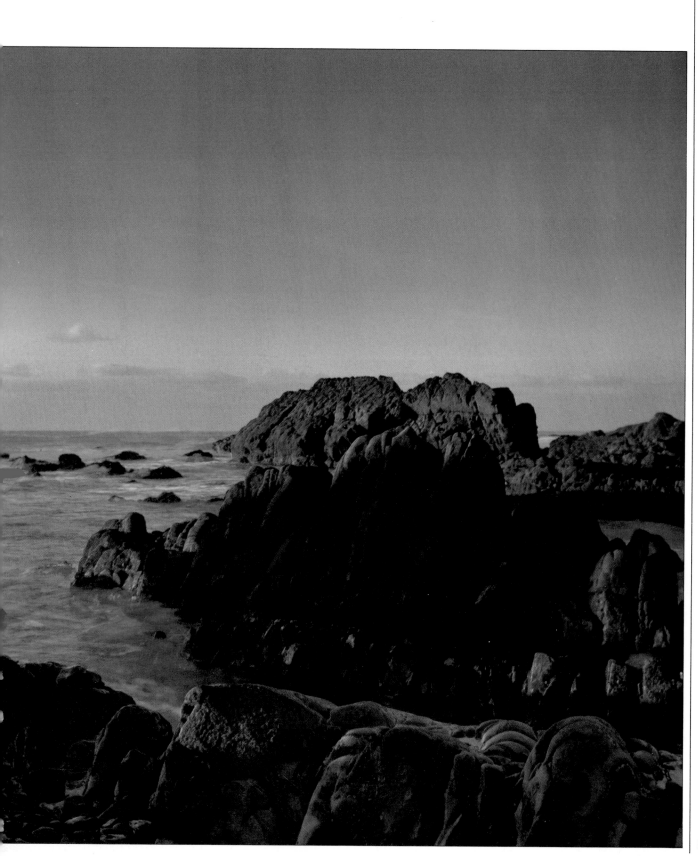

Photography through screens

A screen in front of the lens can turn pictures into colorful abstracts or overlay a recognizable image with an attractive texture, as in the picture below. You can make a screen of this sort from practically any clear or semitransparent material. Glass or acrylic sheets with textured surfaces are good choices. Alternatively, apply a diffusing medium to clear acrylic or glass, as was done for the picture below. To create this image the photographer smeared petroleum jelly across a plain sheet of glass: for a more permanent screen you can substitute varnish or clear nail polish for jelly. And by using inks, paints or dyes, you can add color to the image, as the picture below at right shows.

The focal length of the lens, its aperture, and the distance between the screen and lens will all affect the appearance of the picture, so that by varying these factors you can produce many different effects with the same screen. For example, if the screen is very close to the lens, the resultant image will be very diffuse. But if you shift the screen closer to the subject, outlines will become more easily recognizable – as in the image at right – though details will still be blurred.

The effects of aperture and focal length are less easy to predict. You should experiment by changing lenses and by stopping down the diaphragm, but always be sure to use the camera's depth of field preview button to check the viewfinder image before taking the picture.

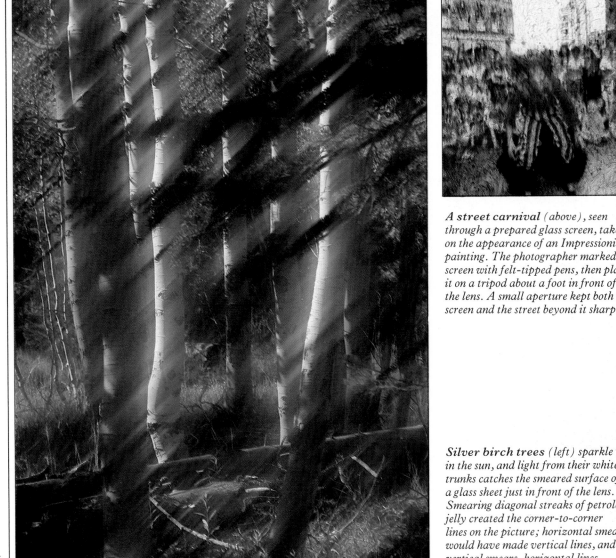

A street carnival (above), seen through a prepared glass screen, takes on the appearance of an Impressionist painting. The photographer marked the screen with felt-tipped pens, then placed it on a tripod about a foot in front of the lens. A small aperture kept both the screen and the street beyond it sharp.

Silver birch trees (left) sparkle in the sun, and light from their white trunks catches the smeared surface of a glass sheet just in front of the lens. Smearing diagonal streaks of petroleum jelly created the corner-to-corner lines on the picture; horizontal smears would have made vertical lines, and vertical smears, horizontal lines.

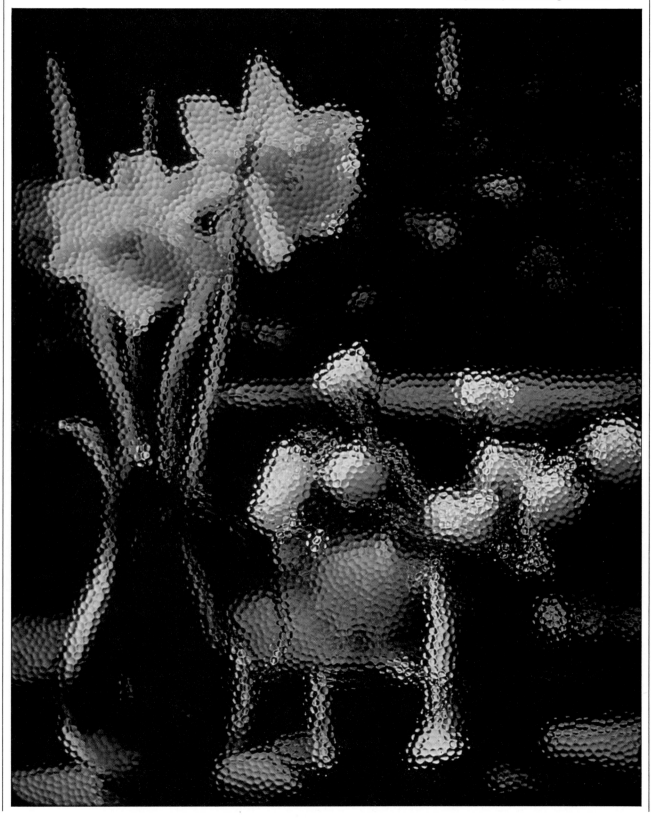

Spring flowers in vases stand behind a pane of textured glass placed in front of the camera. The shaded background contrasts strongly with the sunlit blossoms, preventing the composition from looking cluttered.

Multi-image filters

Thread a multi-image filter onto the front of your lens, and with a single press of the shutter release you can create a picture that has all the appearance of a double or multiple exposure, as shown below. The polished facets of the filter bend rays of light before they enter the lens, so that several identical views of the subject reach the film. The arrangements of repeated images created by multi-image filters vary greatly. Usually there is one dominant image and a series of weaker, displaced ones.

When using a multi-image filter no exposure adjustments are necessary but you must choose your subject carefully. A filter that has five or more facets will scramble a complicated subject, making an almost unrecognizable picture. As in the picture of the car on the opposite page, it is best to choose a subject with very bold outlines and to use a filter that creates just three or four subsidiary images, especially if you want to generate a sense of motion.

Even when using filters of a simple design, you should try to ensure that at least one of the displaced images falls on a dark part of the frame. If the background is light, the images will be washed out and pale. Remember also to use the depth of field preview control, because the subject's appearance will change according to the aperture chosen.

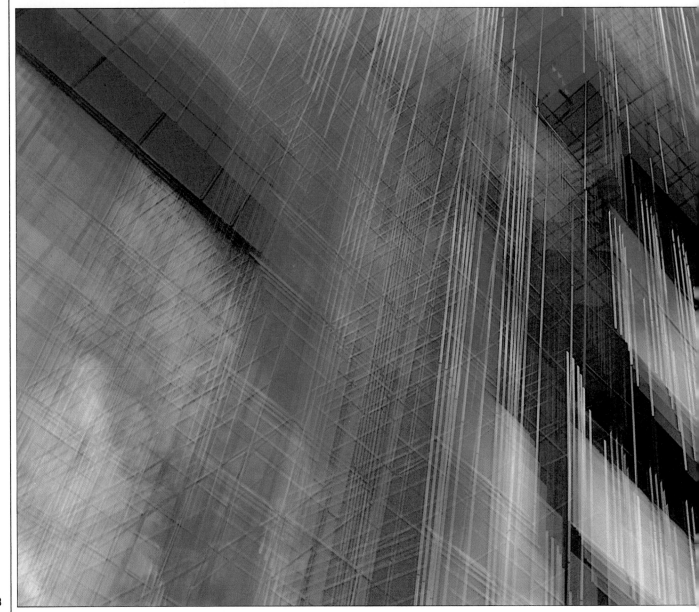

An office building, faced with
mirrored glass, forms a forest of silver
lines when seen through a parallel-image
filter, which has a row of parallel sloping
facets across half of the front surface.

A stationary car reflected in water
appears to leap forward, aided by
a special multi-image filter which gives
an effect of motion. The background
showed up the repeated images clearly.

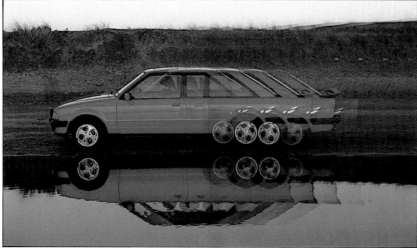

A neon sign bursts with lights
as a zoom lens and a multi-image
filter distort the glowing profile. The
photographer turned the filter while
zooming during the one-second
exposure, to make the outer images
rotate around the central one.

How multi-image filters work
Filters for multiple images are just
glass or plastic blocks, cut and
polished like the surface of a gem.
The position and number of the facets
determine the appearance of the
picture. For example, the flat central
face of the prism above allows light
to reach the film directly, while
the sloping faces form four images
surrounding the central one.

Starburst and diffraction filters

Dazzling flashes of sunlight on a blue pool of water enchant the eye, but on film they often look disappointing. A starburst or diffraction filter can restore the brilliance of the reflected light, as in the picture below, and create an image that more closely resembles what you remember seeing at the moment you released the shutter.

Tiny grooves on starburst filters and diffraction filters, as shown at the top of the opposite page, spread light from the bright highlights into the darker areas of a picture. Thus, both types of filters work best with scenes that show very bright subjects on a dim background. At night, for example, they enhance the twinkling brightness of street lights seen against the dark sky. A diffraction

filter has an additional effect: it splits light into component colors, surrounding each bright highlight with rainbow-colored streaks or with halos, as at bottom right on the opposite page.

The effects of starburst and diffraction filters depend on the focal length of your lens and on the aperture you are using. However, the image in the camera's viewfinder does not always show precisely how the picture will appear, even if you stop the lens down to the working aperture. Take pictures at several different apertures, and choose the best effect after you have processed the film. Avoid using either a starburst or diffraction filter when a subject has a lot of fine detail; because both filters cause some diffusion, the picture may look blurred.

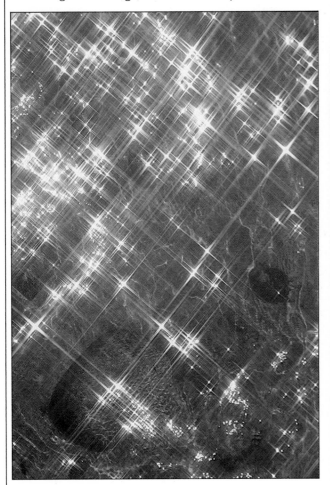

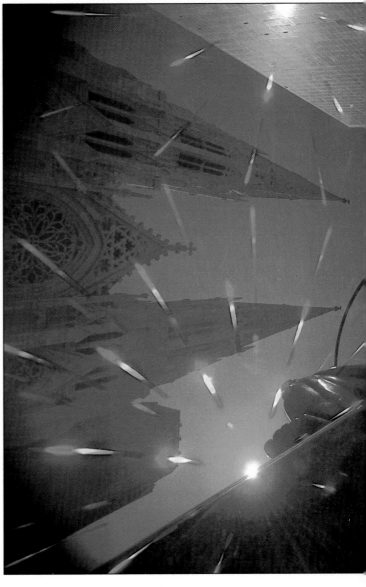

A rock pool glitters in the sun. By attaching a starburst filter to the lens, the photographer turned each reflection into a four-point star. He also oriented the spikes of each star diagonally across the frame by rotating the filter an eighth of a turn.

Choosing a filter

The pattern and spacing of lines etched on a starburst filter, illustrated below at right, control the appearance of the spokes that radiate from each light source. In the picture sequence, parallel lines create two-point starbursts (1), whereas lines at 90° and 22° produce four and 16 spikes on each highlight (2 and 3). On diffraction filters, the lines are too small and closely spaced to see; you can observe their effect only by holding the filter to the light.

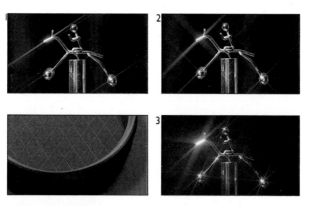

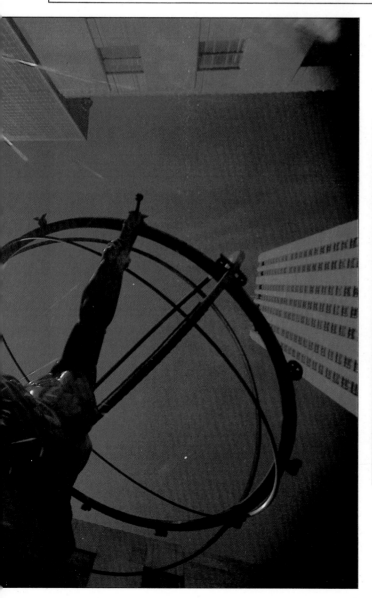

A misty window (below), when seen through a halo diffraction filter, spins rings of color around the reflected afternoon sun. By drawing a black curtain behind the window, the photographer ensured that the spectrum of colors appeared rich and saturated.

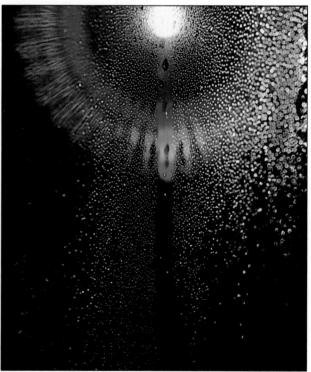

Spears of color (left), created by a diffraction filter, spill from the sun and its reflection in this upswept view of Fifth Avenue near St Patrick's Cathedral in New York City. Underexposure, and an additional magenta filter, helped make the rainbow streaks more prominent.

Transposing film

A simple way to obtain unusual color effects is to use a film that is incorrectly balanced for the light source. Daylight-balanced film, intended for use in natural light settings or with flash, is extra sensitive to yellow or red light, because daylight is predominantly blue. Tungsten-balanced film, on the other hand, is designed to make up the deficiency of blue in tungsten light or candlelight.

Color transparency film gives the best transposed effects. Daylight film in tungsten lighting gives a warm yellow tint to a scene; tungsten film in daylight records a cold blue cast. The depth of color depends not only on the type of light source but also on its intensity. For example, tungsten film used in weak, diffused daylight produces a subtle color cast, as in the large picture below. For more dramatic effects, take your photographs outdoors at dusk, or just before dawn, when the natural light is very blue. To deepen the colors, simply underexpose by half to one stop.

When aiming for a strong color effect, choose the subject with care. A blue cast will make yellows and reds look muddy. But a scene of water and sky, such as the one below at left, can produce a beautiful atmospheric image with tungsten film.

Another approach with tungsten film is to juxtapose a naturally-colored foreground with a rich blue background by lighting the foreground with a tungsten photolamp or by covering the reflector of your camera flash with a No. 85B orange filter.

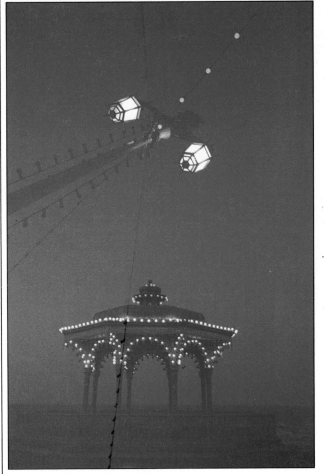

A seaside pavilion is picked out in lights against the deep blue of water and sky. The photographer used tungsten-balanced film at twilight to obtain the strong color cast, and made a double exposure to include the ornate street-light at an unusal angle to the subject.

Brilliant green light bathes the matted branches and gnarled trunk of an old tree. The photographer used daylight-balanced film to intensify the unnatural color of mercury floodlights.

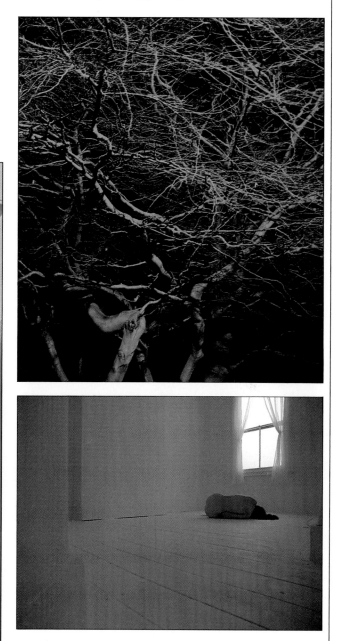

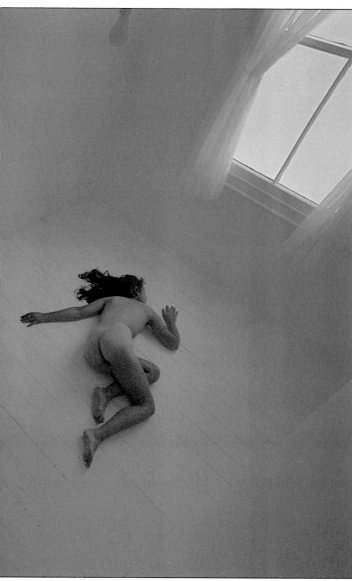

Soft sunlight through a window records a nude's natural skin tones on daylight film (*above*). By switching to tungsten film (*left*), the photographer gave an eerie bluish tinge to the scene, photographed in the same light but with a change of camera angle and pose.

Infrared color film

Of all the special film types used for creative effects, infrared color film is perhaps the most popular. Since the sun and most artificial light sources emit invisible infrared radiation, the film offers photographers a completely new palette of bizarre colors. Kodak Ektachrome Infrared film, available in standard 35mm cassettes, is sensitive to visible light as well as to infrared radiation. With appropriate filtration, its unusual color response turns ordinary scenes into vivid color fantasies, such as those shown on these two pages.

Infrared film is designed for use with a No. 12 yellow filter to remove blue light. Subjects that reflect infrared radiation intensely, such as healthy vegetation, show up as bright red or magenta; red flowers or fabrics appear yellow; and other colors are also distorted. But to vary the effects, try other filters, such as a No. 25 red to make skies green or greenish yellow.

Infrared film has a narrow exposure tolerance, less than half a stop each way. It is balanced for use with a film speed setting of ISO 100 and a No. 12 filter; the exposure will be approximately correct if you follow a reading taken with your TTL meter before attaching the filter. With any other filter you will need extra exposure. Always bracket two stops either way at half-stop intervals. Focusing is more complex than with conventional film, as explained in the box opposite.

Store infrared color film in a freezer, but allow it to warm up again before use. Process as soon as possible after exposure. You may have difficulty finding a lab that can process your infrared film; if so, contact Kodak for advice on where to go.

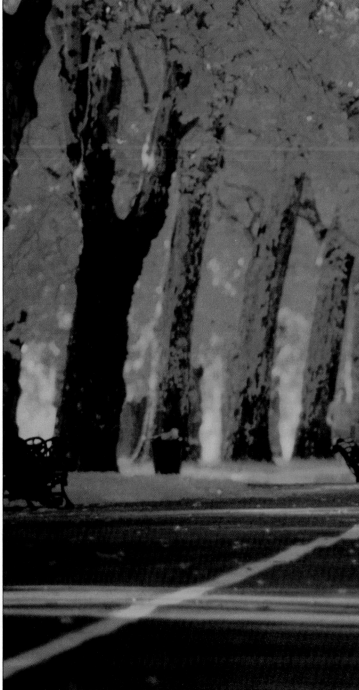

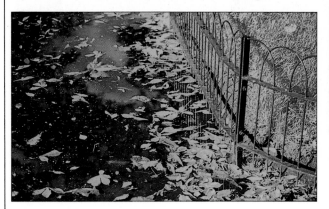

A close-up of a low fence and a leaf-strewn path after a rainfall acquired subtle, muted colors when recorded on infrared color film with a No. 15 yellow filter. The photographer bracketed exposures and chose this one as the most acceptable result.

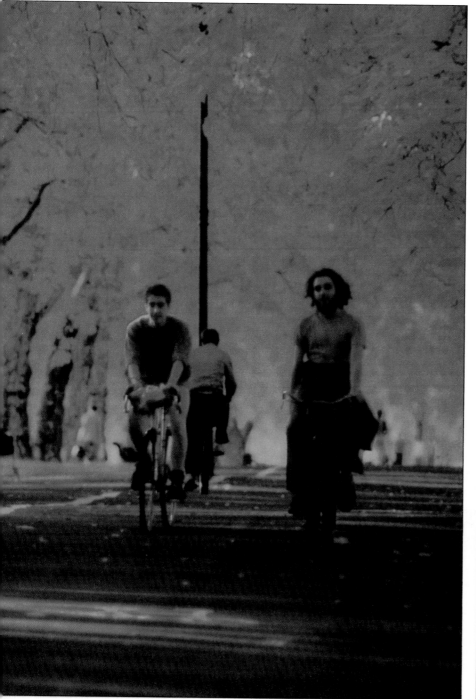

Focusing with infrared film

If you focus on a subject lit by visible light, the infrared that the subject reflects will form a blurred image. Ordinary film is sensitive only to visible light and thus "ignores" the out-of-focus infrared image. But infrared film is sensitive to both infrared and visible light.

With wide-angle and normal lenses, the image that infrared forms is only slightly blurred, and you can bring it into focus by stopping the lens down to f/8 or smaller. But with telephoto lenses, the blurriness is greater, and you must first focus visually, then set the subject distance midway between the regular focusing index and the special infrared index mark on your lens (see below). Finally, stop down to f/11 or a smaller aperture.

Cyclists on a tree-lined avenue are shaded by a tunnel of foliage arching over their heads. Infrared film used with a No. 25 red filter turned the green foliage red, but produced other colors that are realistic. The total effect is a mellow, autumnal mood.

A stream bubbles over rocks between clumps of luxuriant ferns and grasses. Infrared film used in combination with a Wratten No. 12 filter produced a hallucinatory effect, nightmarish but beautiful, although the colors of the rocks were recorded relatively accurately.

Infrared black-and-white film

With black-and-white infrared film in your camera, you can – quite literally – see the world in a new light. This film enables you to reverse totally the tones of common subjects. Water and blue sky appear black and plants look snowy white, as shown below and at right.

Black-and-white infrared film needs special care in handling and exposure. It has a short shelf life, so few dealers keep it in stock, and you may have to put in a special order. Once you have the film, store it in a freezer until an hour or two before you plan to take pictures. The lighttight velvet-covered lips of a 35mm cassette let through infrared radiation, so always unpack the film and load and unload the camera in total darkness.

To give your pictures maximum impact, you must use a filter over the camera lens – either a very deep red filter (No. 70) or a visually opaque filter (No. 87). Focus your camera before attaching the filter, then turn the focusing ring until the subject distance is alongside the infrared index engraved on the lens barrel. This small adjustment compensates for the difference between the positions of the images that the lens forms by visible light and infrared radiation. Before putting on the filter, you should also take a meter reading and use it as an exposure guide around which to bracket your pictures. With Kodak High Speed Infrared Film and a No. 70 filter, set a film speed of ISO 50. With a No. 87 filter, set ISO 25.

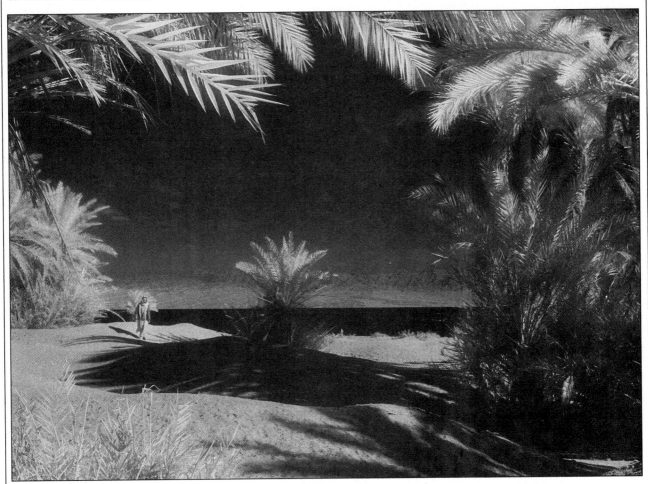

A lake framed by palms turns black when photographed on infrared film, because its cool water reflects only the visible light and absorbs infrared radiation. To ensure that no visible light reached the film, the photographer used a No. 87 filter.

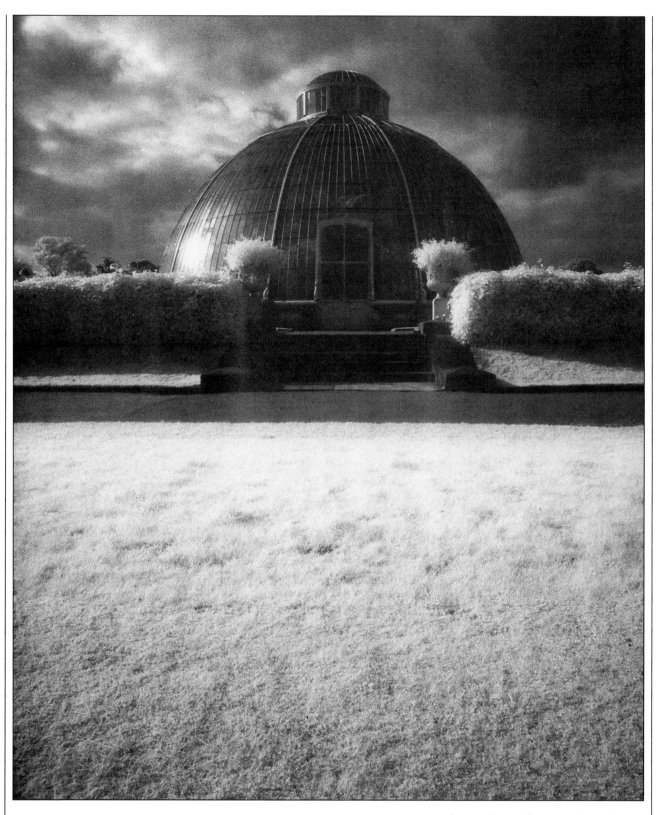

A greenhouse dome stands out above white grass and hedges – as if unseasonal snow has blanketed the vegetation. The infrared film that caused this tonal change also recorded the shadows as inky black, further complicating the strange "weather" effect.

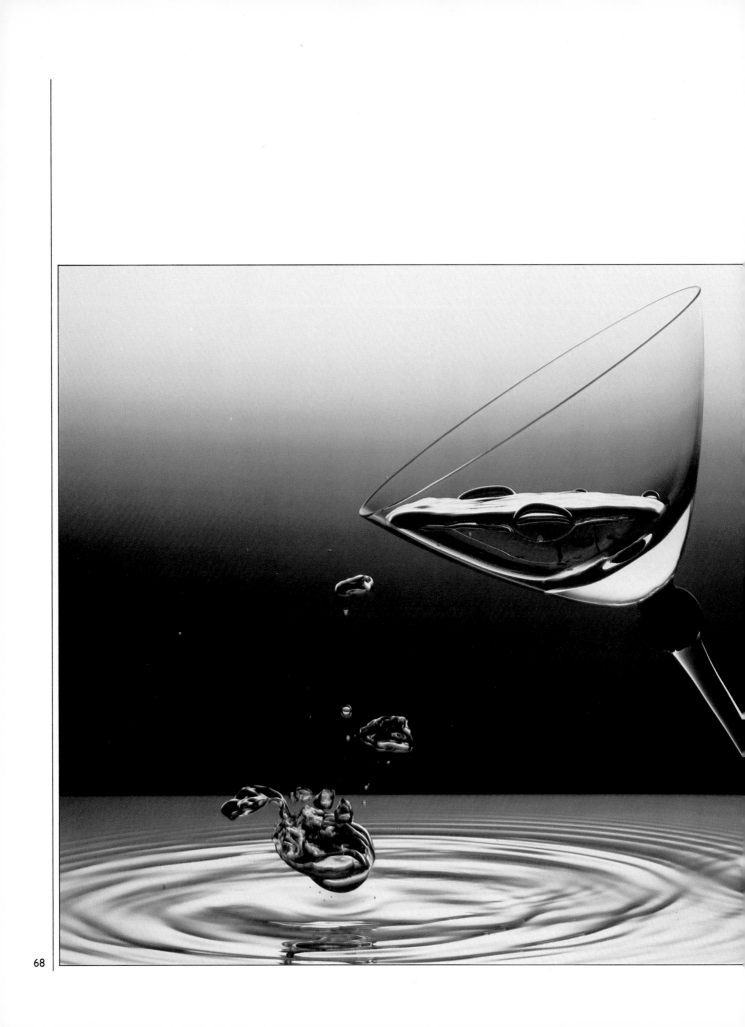

ILLUSIONS IN FRONT OF THE CAMERA

There is no limit to the number of ways a photographer can manipulate the reality the camera sees and records. Inventive use of props and models and other front-of-the-camera aids can produce images that baffle the eye and stimulate the imagination. Commercial photographers who create arresting pictures for posters, record jackets and other forms of advertising or packaging have an extensive repertoire of special effects. You can draw upon the same versatile techniques to produce images that speak eloquently for themselves, such as the gravity-defying wine glass at left. And with a little initiative you can invent methods of your own, for photographs with an individual stamp of fantasy.

Setting up a convincing illusion in front of the camera, whether indoors or outdoors, demands patience and a meticulous attention to detail. However, you can generally allow yourself as much time as you need to compose the subject just as you want it. And having arranged the components of the image, you can take as many pictures as you wish, trying a variety of lighting arrangements, exposure settings, viewpoints and camera attachments. Absolute control over the results is one of the great rewards of this approach to special effects. By manipulating every aspect of the scene in front of the lens, you can be creative in the widest sense of the word.

A wine glass, tilted as if by an invisible hand, seems to pour oddly shaped droplets onto a surface of silvery liquid. To see how the photographer achieved this effect, turn the picture upside down. The view was taken through the side of a water-filled fishtank. An assistant lowered the glass into the water upside down, so that it trapped and then released air bubbles. An electronic flash unit froze the motion of the bubbles as they floated upward.

Defying gravity

Skillful use of hidden supports and other techniques of illusion can create convincing scenes that seem to defy gravity. Because the camera records only what is visible to the lens, you can easily disguise the methods you employ.

The setup for this kind of special effect can be as simple or elaborate as you wish. Useful aids to hold objects in place are fishing line or fine wire, which are invisible against a matching background. The same is true of transparent acrylic sheeting. You can bolt or glue props to the surface and fix the sheet to supports beyond the field of view to suggest objects moving through or suspended in midair, as in the picture on the opposite page.

Gravity-defying effects are also quite simple to achieve if you build a set or arrange a situation in which one or more elements are upside down, or are vertical instead of horizontal. Introduce a falling object into the scene, and photograph it using a flash unit. If you turn the resulting picture the other way around, you can get a startling image such as the one below at left.

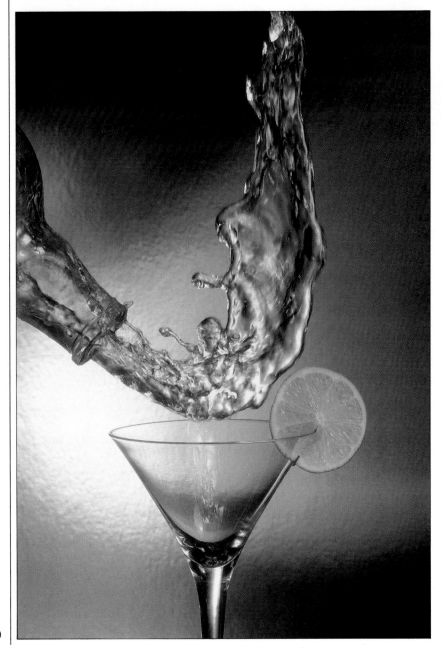

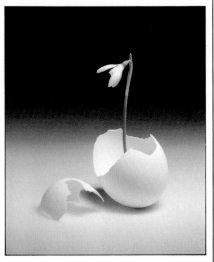

A blossom (above) appears to be hatching from an egg. No complicated preparations were necessary to create this harmonious still-life composition. The photographer ran stiff wire through the stem to hold it upright, then cut away part of the eggshell on the side not facing the camera and attached the wire through the shell to the surface with a small piece of modeling clay.

Water poured from a bottle (left) changes course to flow upward. To create the illusion, the cocktail glass was fixed to an overhead surface and a hosepipe was fed through a hole in the base of the bottle. Electronic flash froze the jet of water. Turning the image upside down completed the trick effect.

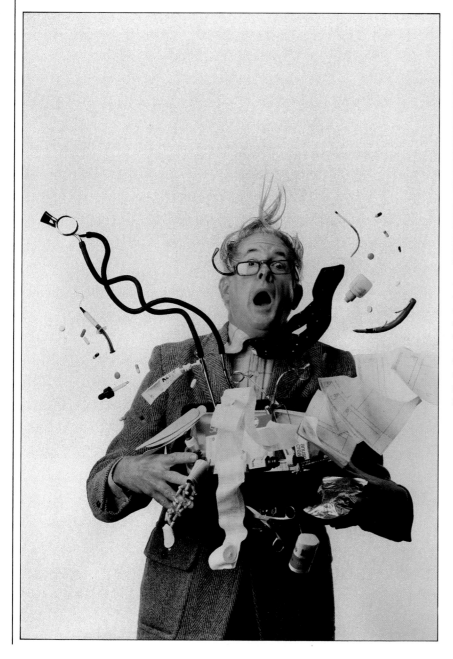

A doctor's bag (left) *disgorges its contents as if its owner were frozen at the moment of a violent collision. The specially made props were all attached to a clear acrylic sheet, which was bolted to wooden uprights out of the camera's view* (as shown above). *Fishing wire was threaded through the stethoscope and tie to hold them up. A wind machine made the subject's hair stand on end.*

Scale models

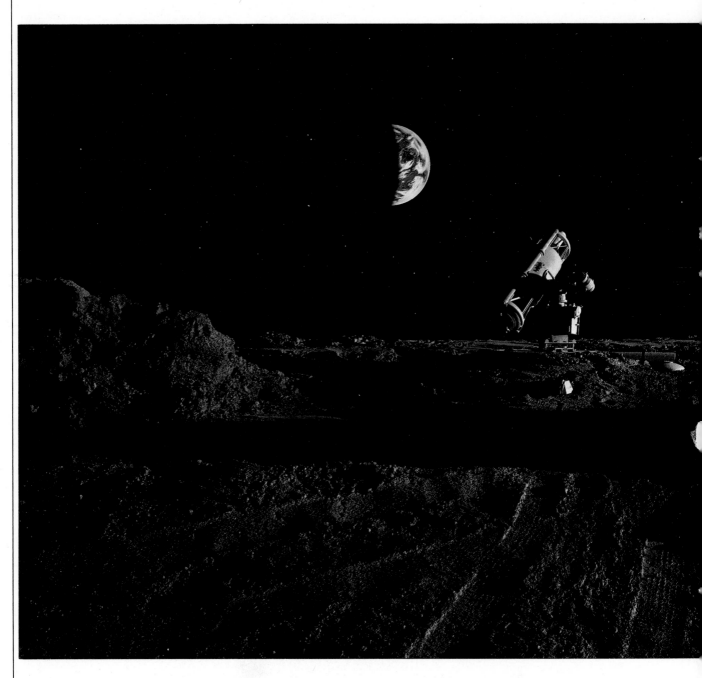

Scale models let you create scenes that would be difficult or impossible to set up in real life. Commercial or home-made models, arranged with appropriate scenery and backdrop on a flat surface, can create remarkably convincing illusions if you make sure that every element of the scene, including the lighting, matches the scale of the subject.

For a natural-looking outdoor scene, as in the picture on the opposite page, sand or a powder such as plaster, baking soda or fuller's earth, used dry or mixed with water, can suggest different types of terrain. For a fantasy image such as the one above, synthetic materials and strange lighting effects may suit the mood and style of the subject.

Working in close-up means shallow depth of field. Set a small aperture, and check through the viewfinder that focus and viewpoint are correct for the scene before you take your picture. Using a wide-angle lens for greater depth of field will also help convey a feeling of distance.

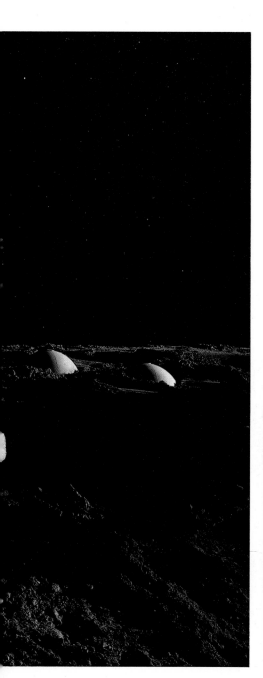

A telescope (left) surveys the heavens from a bleak lunar landscape. First, the photographer marked on the baseboard the area covered by the lens, then modeled the terrain using cement. With the model in position, he set the lens at minimum aperture and made a first exposure of the subject, using a small flash unit to create the hard shadows. The Earth – a stock transparency – and the stars – pinholes pierced in the backcloth – were added in a second and third exposure.

Japanese infantrymen (below) advance toward the camera through high scrub. The 1/35-scale models were arranged on a tabletop (right) with steel wool and dyed ground cork for the tree, teased sisal string for the grass and sand for the dry terrain. The photographer closed in with a 35mm lens to suggest space and distance. He took the picture with electronic flash to make the figures stand out from the background, which is blurred by an aperture of f/11.

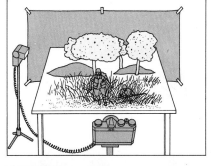

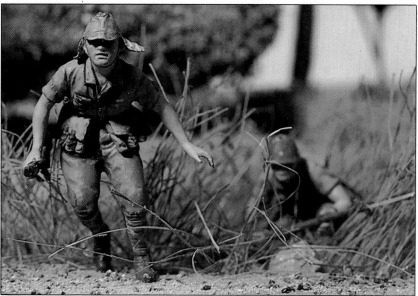

Perspective illusions

If you are photographing scale models or other small objects, you can increase the impression of depth in the picture by building a special set. This was how the photographers who took the pictures shown here created the dramatic perspective effects.

Such "forced-perspective" sets are simple to make. They are based on the familiar principle that parallel lines such as railroad tracks appear to converge in the distance and meet on the horizon. By constructing your set so that apparently parallel lines in fact get closer together as they stretch away from the camera, you can fool the viewer into thinking that the horizon is a great distance away, not just on the other side of the room.

To make the illusion complete, you must build your set so that it appears to obey the other laws of perspective, too. Objects that are actually evenly spaced, such as railroad ties, will appear more tightly packed the farther away they are, so you should also exaggerate this effect, as explained in the box

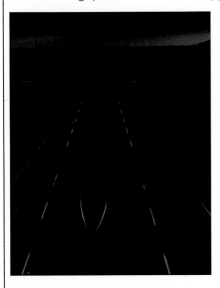

Landing lights *frame the sleek fuselage of an aircraft on a three-foot long "runway." The "lights" are tiny holes drilled in converging lines through a sheet of black plastic, which the photographer lit from below. Colored gel over the holes tinted the rows of lights to complete the illusion.*

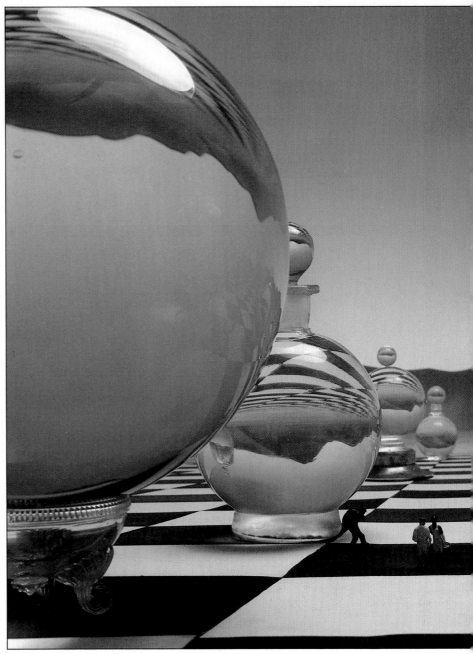

at the bottom of this page.

You may want to go further still and use models of different sizes in different parts of the scene. For instance, in the picture below, the glass globes are all different sizes – the most distant ones are glass marbles. You could achieve a similar effect using the human figures that model shops sell. Place the smallest ones – usually about $\frac{1}{2}$ inch (1 cm) tall – at the back of the set, and bigger ones progressively closer to the camera.

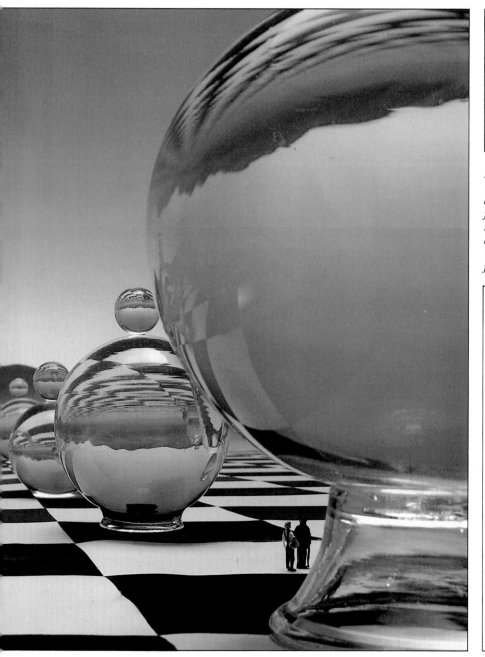

A surreal landscape of globes (left) actually fits onto a tabletop, as diagrammed above. The photographer first painted a checkerboard grid, using the technique outlined below, then made cardboard mountains for the horizon. The figures were scale models designed for use with model-trains.

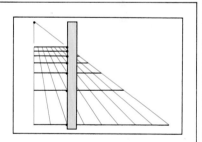

Forcing the perspective
To make a forced-perspective set, draw up a grid as shown above. First, mark a point on the far side of the set where all the "parallel" lines will meet, then rule off lines at regular intervals from this point back to the camera position (blue lines above). To position the lines that cross the field of view, place a ruler across the set (green above) and draw parallel lines where the ruler crosses each converging line. Experiment with different grids by varying the distance to the "horizon," as well as the spacing between lines.

Models and props outdoors

You can make props work more effectively in your pictures by placing them in incongruous or ironic outdoor situations. For example, the skeleton in the picture below at right would not merit a second glance if it appeared without its accessories in a photograph of an anatomy class, and would be only mildly surrealistic in a home interior. But transplanted to a river bank, the bones make a macabre comment on an unsuccessful fishing trip.

For pictures such as these, obviously the props themselves are just as important as the context in which they appear, and many photographers make a point of collecting unusual items, such as the fish's jawbone shown opposite. If you have a particular effect in mind, you may find what you want at a theatrical supply shop. However, with a little imagination, you can often use very ordinary props and still make an image that will amuse or intrigue.

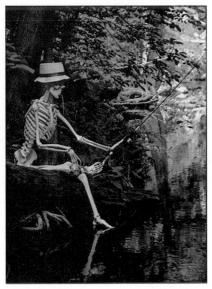

A skeleton (above) beside a creek suggests that patience can be carried too far. The photographer held the bones in this complicated pose by carefully threading them with fishing line, which is so thin that it disappears on film.

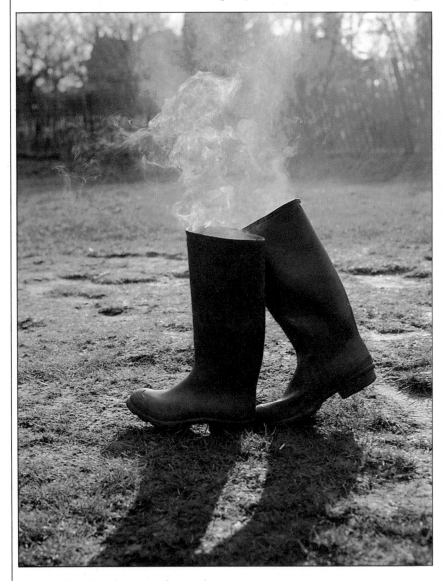

A pair of rubber boots smokes in the sun as if the owner had quite literally gone up in smoke. To create the effect, the photographer supported one boot with wire and dropped in dry ice, which gives off clouds of white vapor as it melts.

A vast jawbone (right) straddles a distant island and suggests a scene from a science fiction film. To exaggerate the proportions of the jaw, the photographer moved in close, using a 24mm wide-angle lens. Backlighting emphasized the bone's translucency.

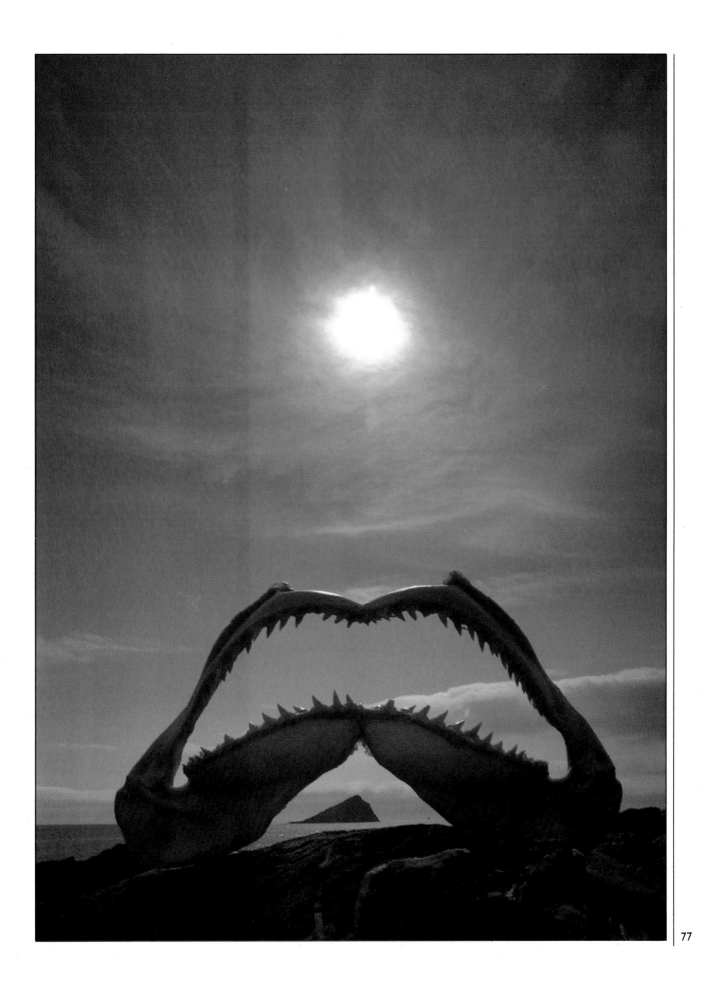

Prints and artwork as props

Various kinds of prints and artwork, used as foreground or background props, can enliven studio setups or add interest to outdoor scenes. To achieve an illusion as convincing as the one below, you need to match the style, mood, scale and lighting of the foreground and background elements very carefully. For example, if the foreground subject throws shadows onto the background, or if there is an abrupt break in perspective, the way you obtained the effect will be obvious at once. However, you do not have to rely on realism for an effective result. For example, in the picture on the opposite page, below, the incongruous combination of elements made an amusing image.

The opposite approach – combining a genuine background with a painted or modeled foreground element – can also produce intriguing images, such as the double-clouds effect at the top of the opposite page. Again, make sure scale and perspective match if you want a convincing illusion.

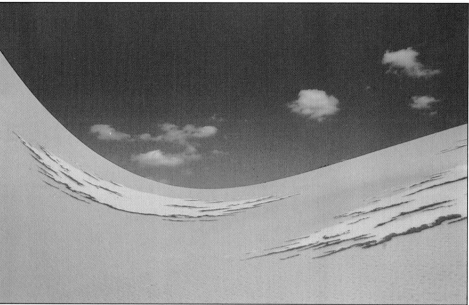

A table (*left*) *laden with mouth-watering traditional fare lends startling realism to a 19th Century scene. The photographer arranged the still-life of food in front of a large reproduction of a painting, carefully aligning the painted table and the real one. The soft, even lighting suggested sunlight coming through the windows.*

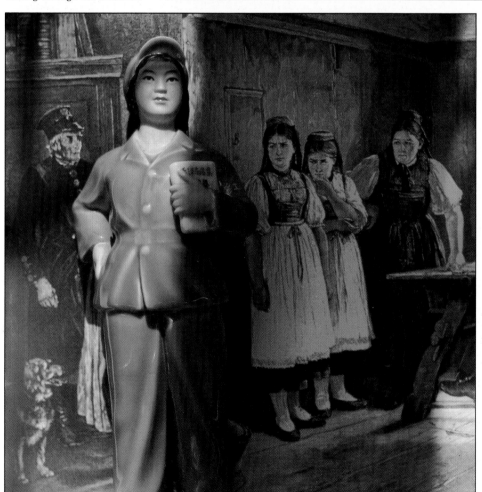

Cloud images (*at top*) *combine in a crisp, abstract composition. A curved sheet of textured plastic with pasted-on clouds was set up outdoors, as diagrammed above. A 24mm lens created a sense of space and distance.*

An Oriental figurine (*left*) *seems to draw disapproving glances from the figures in an old engraving. The clever juxtaposition links the two elements of the image, as well as contrasts the flat, monotone background with the three-dimensional subject in front.*

Patterns of light

Light, the essential element of photography, can also provide a subject in itself. The picture on the opposite page at top left gives a fine example of one of the simplest ways of using light as a subject – moving a small, portable light source, such as a pencil flashlight, during a long exposure. The resulting light trails can be varied by waving the flashlight to make different patterns, using different colored lights or placing a series of different colored filters over the lens during exposure.

With a moving subject you can create beautiful patterns of light and color by using flash as your light source and firing it at spaced intervals during a timed exposure with your camera shutter on its B setting. This technique will give you a stroboscopic effect, with the image burning out wherever shapes overlap, as in the gyroscope picture below. Reflective and transparent materials are another good source of light-pattern images, as exemplified by the effective wine glass still-life on the opposite page at bottom left.

For successful results with any of these techniques, you need darkness so that the light patterns will show up clearly. Indoors, use opaque cloths to black out the room. Outside at night, try experimenting with mixed light sources to produce unusual effects in a straightforward scene, as in the picture opposite at far right.

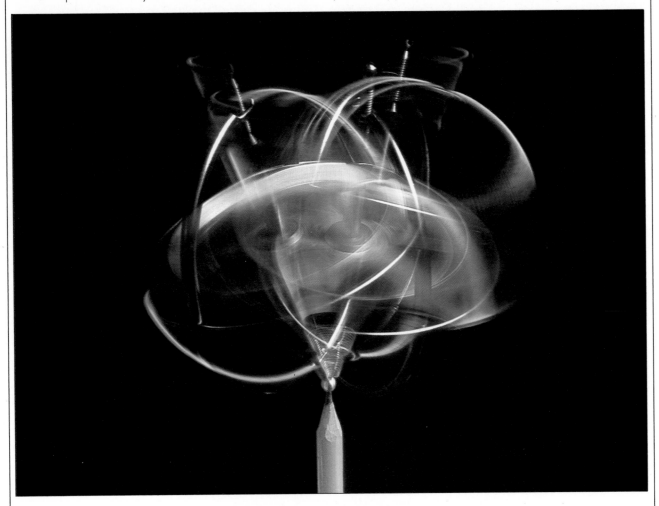

Gleaming arcs describe the fluid rotations of a toy gyroscope balanced on the point of a pencil. The photographer used a portable flash unit and fired several bursts of flash at intervals during a time exposure, to combine areas of sharp detail with soft moving color.

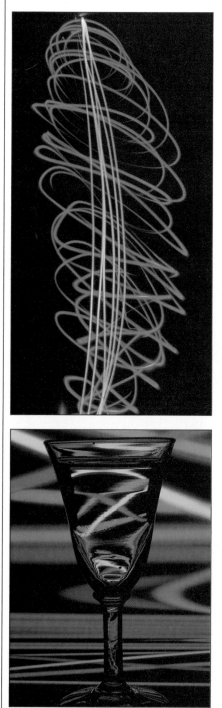

Vibrant squiggles (left) create a dynamic pattern against a solid black background. The effect was produced by swinging a flashlight during a double exposure lasting a total of 40 seconds, with a change of colored filters for sizzling contrast.

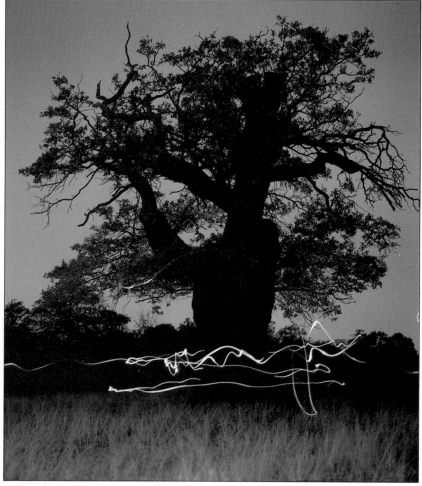

Ribbons of color set off the elegant shape and clarity of a wine glass. The photographer cut strips in black cardboard, fixed different colors of cellophane to the back and lit this backdrop from behind. A black acrylic sheet under the glass reflected the background colors.

Light trails enliven a nighttime landscape. With the camera on a tripod and the shutter locked open for one minute, the photographer ran about with a flashlight to make the light patterns. Then he fired an electronic flash to light the grass in the foreground.

Projected images /1

By projecting a color slide onto a textured or three-dimensional surface and photographing the result, you can obtain arresting images, such as the one below. Light-colored surfaces are best for this technique. Instead of a slide, you can try projecting lacy fabric or other pattern-forming materials held in a glass mount.

Use an ordinary slide projector and a tripod-mounted camera. For greater versatility in composing the picture, attach a zoom lens to either the camera or the projector, or both. If you are projecting onto a textured surface, place the camera alongside or just above and behind the projector; this will minimize shadows. Photograph in the dark with the projector lamp as the only light source, and use tungsten-balanced slide film, or daylight film with a No. 80A or 80B correction filter. A high-speed film and a slow shutter speed will compensate for the relative dimness of the light from the projector.

When projecting onto a three-dimensional subject, such as the woman's head on the opposite page, you can prevent projected light from falling onto the background by aiming the projector at an angle more oblique than that of the camera; a black background will absorb stray light and provide a good contrast. Oblique projector angles can also be used to produce fascinating distortions of the projected image.

Manic red eyes stare from a distorted face (left). The photographer first took a stiffly posed head-and-shoulders portrait of the subject against a black backdrop, using a camera-mounted flash unit pointed straight at the face to give a "red eye" effect. He then projected the resulting slide onto a large sheet of torn white paper and rephotographed it to give an image with overtones of terror.

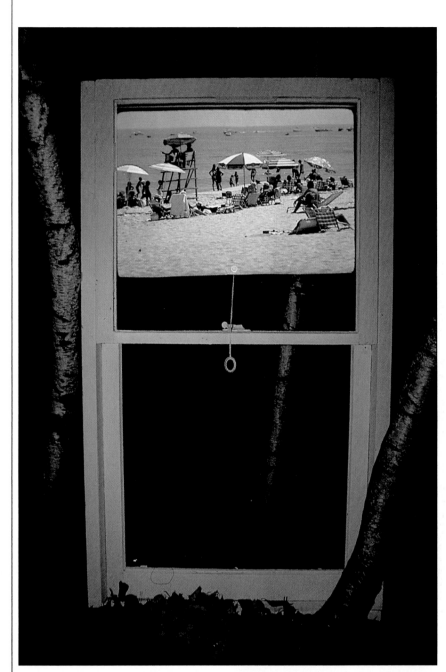

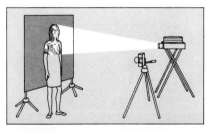

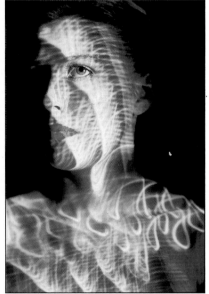

A beach scene (above) adds daytime colors to a nighttime view of a window frame and shade propped up between trees. The picture is a double exposure. Using a flash unit, the photographer took the first view with the shade raised. For the second exposure he lowered the shade and, using an electrical outlet from a nearby house, projected a slide onto the blind without any additional lighting, as diagrammed at right.

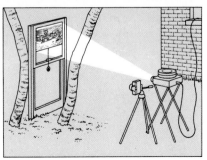

A woman's head (above) glows with swirling shapes. For this psychedelic effect the photographer took a close-up of paper currency on color slide film. Then, in his studio, he projected the slide obliquely onto the girl, using the camera and projector setup diagrammed at top. Before photographing the result, he checked the viewfinder to ensure that no light from the projector fell onto the black backdrop.

Projected images/2

Normally, you use a projection screen to display slides. But images projected onto a screen can also be incorporated in new compositions and then rephotographed. Or you can use the texture of a home-made screen to produce an image that is grainier and more atmospheric than the original transparency, as in the example below at left.

With two slide projectors you can combine different images on a screen to produce effects such as the one opposite. Make sure one image has light areas, so that details of the second image show through. If you wish, fix a piece of black cardboard in front of the projection lens to mask off unwanted parts of the image before rephotographing.

By projecting onto the back of a screen, you can combine a projected background with a foreground subject placed between the camera and the screen. The screen should be textureless, translucent material such as thick tracing paper. It can be difficult to match the lighting convincingly. One way around this is to use a foreground subject that does not require studio lighting, as in the image below.

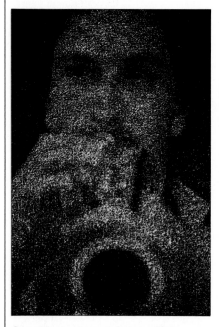

Speckly texture (above) *adds atmosphere to a portrait of a trumpeter. The photographer obtained the effect by projecting a slide onto a metalized fabric screen and then rephotographing.*

Two silhouetted shapes (right) *combine in an intriguing composition. The photographer projected the background image onto the back of a screen and set up a cut-out figure in front, between the camera and the screen, as diagrammed above. No extra lighting was needed.*

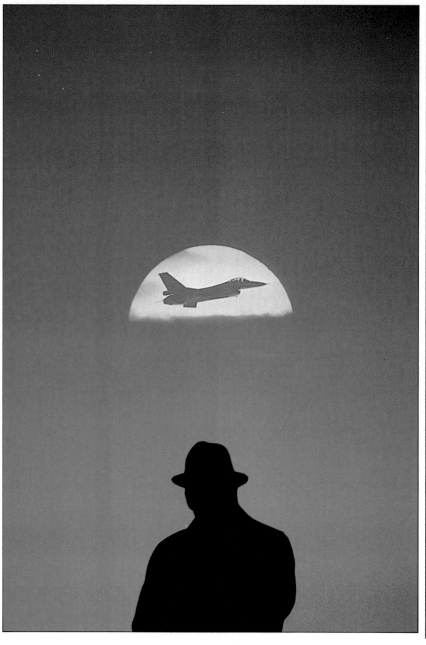

*A **wistful face** appears between clouds and foaming surf. The photographer set up two slide projectors, one at each side of the camera, and projected the two transparencies onto the screen simultaneously for a superimposed effect.*

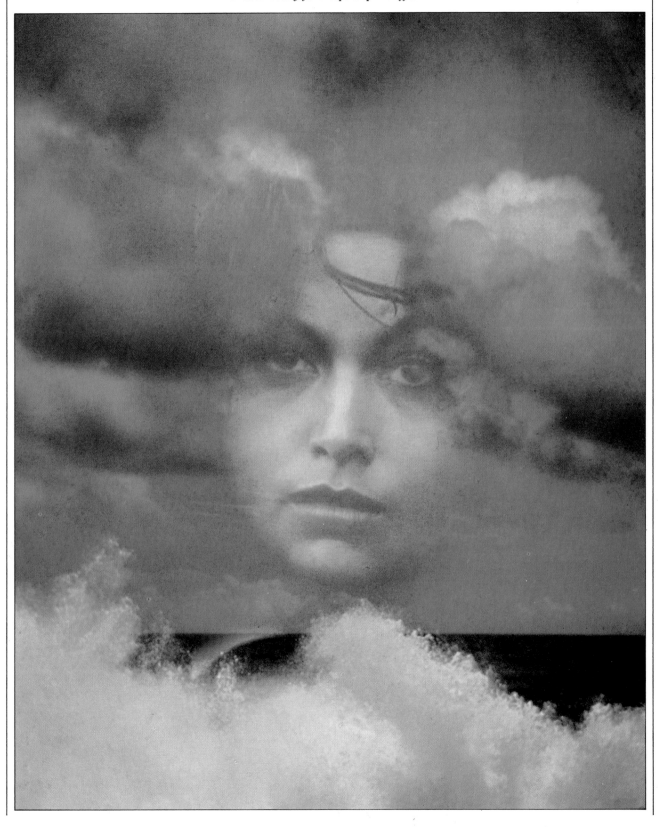

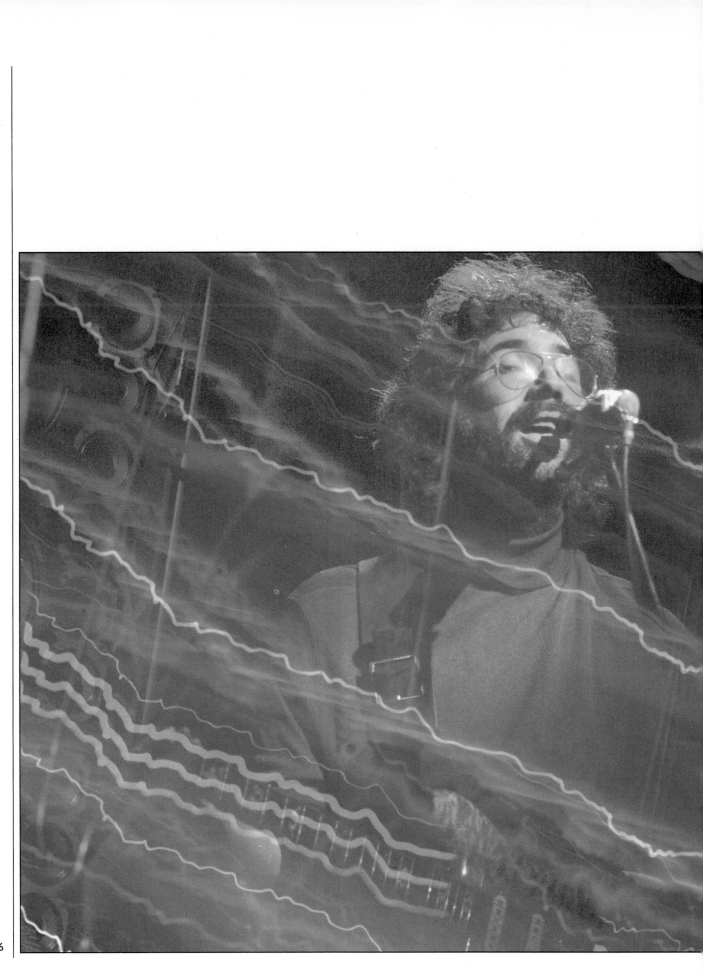

MANIPULATING THE IMAGE

For the creative photographer, exposing the film need not be the end of the picture-making process. Many post-camera techniques, described in detail in this final section, let you alter an image for special effects, or produce an entirely new picture by combining images.

One possibility is to deliberately mismatch film and processing, so that you obtain color negative slides or prints with bright, unnatural hues. Another technique is to alter the surface of transparency film by scratching, heating or applying chemicals to the emulsion. By sandwiching slides together, you can create multiple images that can be mounted as one slide and projected or copied. Or you can make a series of exposures in a copier to combine two or more slides on one piece of film – the technique used to achieve the dynamic effect at left. For prints, montage is a fascinating way of building a composite image: you can combine elements from as many pictures as you wish and copy the result. Such techniques, used either to heighten reality or to conjure up fantastic images, provide unlimited opportunities to develop your imaginative powers and personal style.

Brilliant zigzags of light convey the pulsating electric energy of a rock concert. The photographer made two transparencies: one was of the guitarist; the other was of light trails from an amplifier, made by moving the camera up and down during a one-second exposure. He then double-exposed both transparencies in a slide copier to produce the composite image.

87

Sandwiching /1

Sandwiching is the term for combining two slides in one mount to produce a composite picture. The effect may be either naturalistic or surreal. As the two images on this page show, the technique is especially useful for dramatizing an uninteresting sky: for example, you can add a sun, a moon, clouds, lightning, a flock of birds or an airplane's vapor trail to heighten the impact of a composition. (When photographing the sun, never look at it directly without protection; with an SLR, place a 5.0 neutral density filter over the lens and stop down manually to the smallest aperture.)

Generally, each slide in the combination should be overexposed by half a stop or a stop, or the final image will be too dense. However, no exposure adjustments are required when one of the subjects is a silhouette with a pale background.

For a realistic effect, you should usually match the two images in scale, perspective, and the quality and direction of the lighting, although you can sometimes use these discrepancies creatively. Avoid too much detail or the result will look cluttered.

The procedure for sandwiching, diagrammed on the opposite page, is extremely simple. Apart from

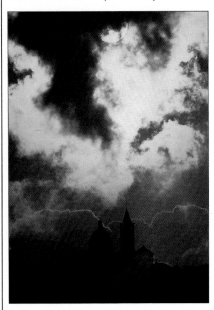

A town (above), boldly silhouetted against distant hills, sits beneath threatening clouds and a half-obscured sun. The photographer combined a view taken on travels in Italy with one of the skyscapes that he photographs and files for such sandwiches. The bright cloud outline passing through the top of the tower adds a restrained touch of unreality to the composition.

A windsurfer's sail (right) forms a triangle that neatly bisects the sun. This is a sandwich of two images – the surfer was photographed with a 600mm lens combined with a x1.4 converter for extra magnification; the sun was taken with the sandwich in mind, using a 500mm lens fitted with an orange filter and a strong neutral density filter. The filter and small aperture protected the photographer's eye from the sun's rays; but as an added precaution he also wore sunglasses.

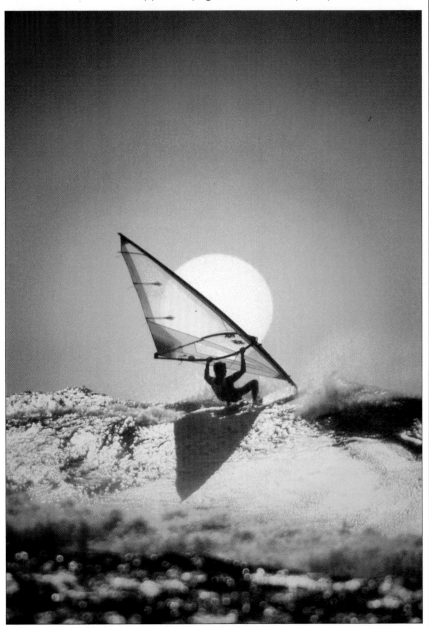

slides and plastic mounts, all you need are a craft knife, adhesive tape, and a soft brush or can of compressed air for cleaning the slides. It also helps to have a light box and a viewing glass, to facilitate sorting through slides and previewing the effect of various pairings. Having made your sandwich, you can show it in a slide viewer, duplicate it in a copier (see pages 92-3) or send it to a photo lab for printing.

The key to successful sandwiching is planning. For most photographers, the starting point is to identify a slide that will work well in a sandwich. If the slide you choose is too dense, you can make a paler duplicate by overexposing in a copier. Once you have selected the first image, you will often have to create the second especially for the sandwich. If so, take a sketch of the first image with you as a guide to composition. When you find the right subject, bracket by overexposing at half-stop intervals.

Another approach is to sandwich a slide with a piece of colored gel or paper rather than with another slide. For example, you can try using blue gel to give a moonlit effect to a landscape. In the photograph below at left, the lake owes its golden appearance to an experiment of this kind.

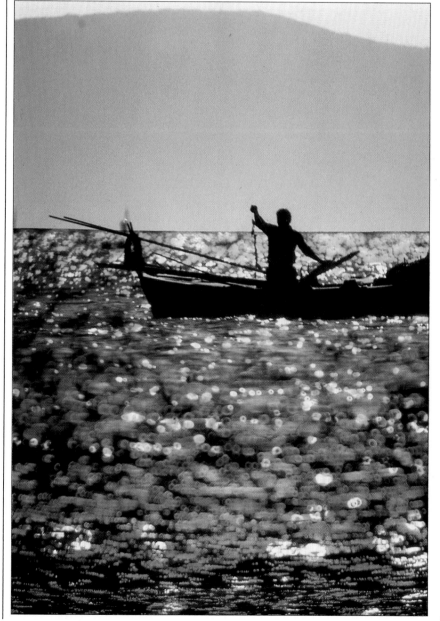

Making a sandwich

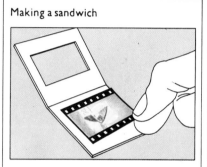

1 – Remove each slide from its mount. Very carefully use a craft knife to ease the cardboard pieces apart; if the mount is plastic, open it with your fingers. Handle the slides by the edges only. Clean each slide with a soft brush or jet of compressed air.

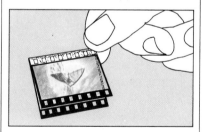

2 – Place the slides together. Using a narrow strip of transparent tape, join the slides along one edge, taking care not to cover any of the image. Remount the resulting sandwich. You can buy special mounts for this or reuse discarded mounts.

A fisherman (left) in a rowboat, silhouetted against a lake glittering with strange colors, examines his tackle. For this effect the photographer sandwiched a fishing scene, taken with a 500mm mirror lens, with some fogged film cut from the end of an exposed roll.

Sandwiching/2

The most adventurous use of sandwiching is to combine images in an ambiguous or enigmatic way, so that your final picture suggests daydreams and fantasies, as in the picture opposite at top, or juxtaposes subjects that could not possibly coexist in reality.

When you are not seeking to produce natural-looking results in a sandwiched pair of images, you can give your imagination full rein. If anything, the more unlikely the combination of subjects, the more successful the sandwich will be. Look for combinations of pictures that defy photographic convention: if the sandwich looks best when one image is upside down or turned on one side, do not hesitate to combine the slides in this way. For example, in the picture below, the photographer has reversed one of the slides so that the shadows fall both left and right. This simulates an impossible lighting effect, increasing the impact of the image.

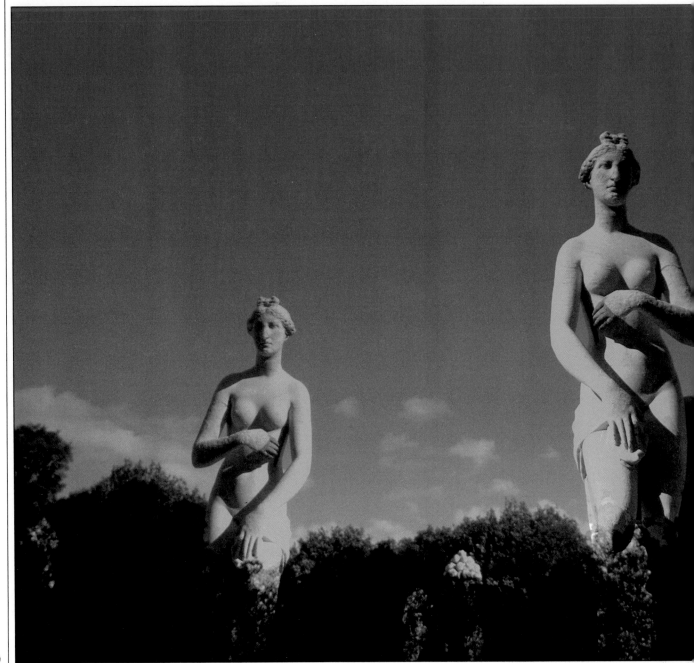

Stone figures tower above dense green forest – the result of sandwiching two similar images in a single slide mount. To exaggerate the height of the statues, the photographer chose pictures taken from below.

A swirling sky adds an air of malice and foreboding to a posed picture taken on a pleasant country walk. The blue-green texture filling the upper part of the frame is actually a sandwiched image of pounding surf.

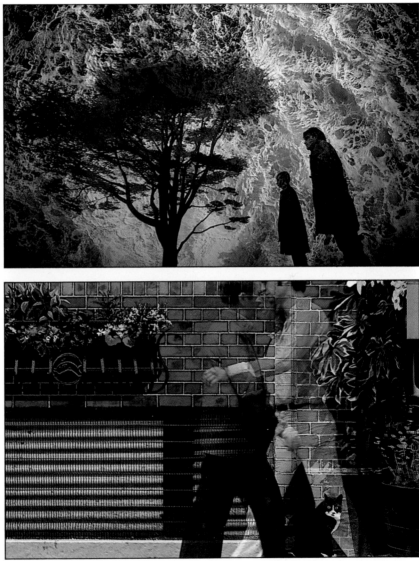

Passing strangers – photographed on successive frames from the same camera position – seem to meet and merge when the pictures are sandwiched together. Slight movement of the camera after the first picture was taken gave a ghosted image of the background.

Copying

Duplicating, or "duping", a slide can mean much more than just making an identical copy. You can use the duping equipment described in the box opposite to copy a sandwich; to combine two or more transparencies in successive exposures on one piece of film; to selectively enlarge part of a picture; or to increase dramatically the saturation and contrast of colors.

To combine images, as in the composition below at right, you use the same techniques as you would when making a double exposure in the camera. However, a copier has the merit of allowing you to pick images from your entire slide collection.

Copying just a small area of a slide gives you the opportunity to improve a composition by cropping

out unwanted detail. The greater the degree of enlargement, the coarser the grain of the image; but you can sometimes make creative use of this effect, as in the picture below at left.

Unless you use the more advanced type of copier shown on the opposite page (3), or special film such as Kodak Ektachrome slide duplicating film, the contrast of your dupes will be higher than that of the original slides. Sometimes this is an unwanted by-product of copying, but you can turn it to advantage for special effects. For example, the photographer who took the picture at far right deliberately copies his slides onto regular film and uses the resulting increase in color saturation to create images of electric brightness.

A river scene at sunset (left) is broken up into a pattern of colored dots by the grain of the film. To evoke the spirit of the painter J. M. Whistler, *whose river paintings are similarly atmospheric, the photographer greatly enlarged a small portion of the original transparency.*

Sinister figures stride across the frame in this composite image. The photographer copied three separate slides onto the same frame of film: the first two showed the silhouetted figures; the third, the windows at top left. To add color, he placed a different color filter over the light source for each of the three exposures.

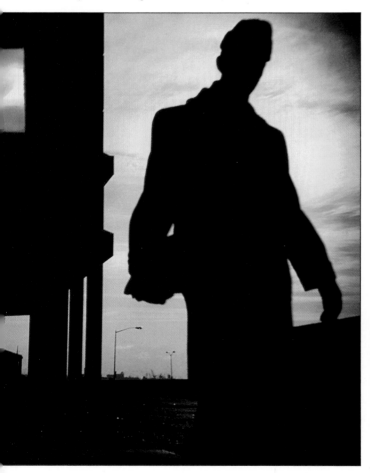

Equipment for slide copying

To make dupes of your slides, you need some extra equipment, but it need not be expensive – higher-priced copiers are simply more versatile. A basic copier (1) consists of just a fixed-focus lens in a tube, with a holder at one end that holds the slide to be copied and a camera mount at the other. The disadvantage of this apparatus is that you can make only same-size copies – you cannot enlarge the original slide. A bellows duplicator (2) is more costly but allows you to close in on any part of the transparency. Both this and a simple copier must be used with an auxiliary light source, such as a small flash unit. The most sophisticated copiers (3) have a built-in light source and may also have a swing-over exposure meter and a device that permits precise control of contrast.

A yellow beach ball balanced on a red car top glows brilliantly against the towering spires of a church. The colors in reality were not nearly as intense – duplicating the slide onto Kodachrome 25 film increased contrast and greatly boosted their saturation.

Montage/1

Montage differs from other ways of creating multiple photographic images in that it demands a degree of hand craftsmanship. This is part of its appeal. Once you have mastered the basic cutting and pasting skills, montage is fun to do as well as creatively rewarding.

The term refers to the art of combining parts of different prints into a single image – usually a composition that you would not be able to achieve with photography alone. The usual approach is to mount a large background print on stiff cardboard and then paste smaller images onto it. All the prints should be on the same grade of paper and be similar in density and contrast.

If scale is critical, as in both the examples here, you may need to use prints especially made to the right size. First trace the background, and then sketch in the other subjects. If you have a home darkroom, use your enlarger to project the negative onto the sketch, adjust the image size to fit, and then make your own prints. Alternatively, take the negatives and the sketch to a photo lab and ask for especially-sized prints.

Unless you want an obvious collage effect, you will need to take great care to disguise the cut edges. First, cut away the unwanted part of the print with scissors, leaving about an inch to spare around the outline of the subject. Using a craft knife with a new blade, score lightly around the outline, penetrating the emulsion only. Then, make a series of small flaps by cutting right through the print at equally spaced intervals from the outline to the edge of the cutout. Place the print face down. By pulling up each flap, carefully tear off backing paper to produce a cutout that is very thin at the edges. To make the cutout thinner still, rub the finest grade of sandpaper over the back, working from the center outward.

If you can perfect these techniques, your superimposed images should merge unobtrusively into the background print. However, if you prefer to cut out each image with scissors and a knife in the ordinary way, you will usually need to retouch the cut edges before assembling – either with a felt-tipped pen or with gouache diluted to match the image tone. After pasting down the image onto the background print, rephotograph the composition.

Nude women in contorted postures fill the gaps in a stone wall. For this montage, the woman was photographed in various positions against a black background, then especially-sized prints were pasted onto the larger print of the wall. Skillful retouching made the cut edges invisible.

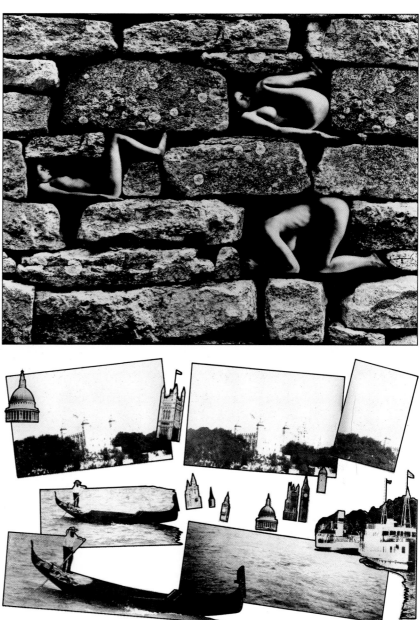

Twin gondoliers (left) scull their Venetian-style craft incongruously down London's River Thames. The river bank is lined with a jumble of famous London landmarks, impossibly duplicated to add to the viewer's bewilderment. To create this fantasy, the photographer made a montage using more than a dozen prints, some of them enlarged twice at different sizes from the same negative. The illustration above shows their outlines.

Montage/2

By working with color prints instead of black-and-white, you can produce montages that are even more startling in their impact, such as those illustrated here. If you want to produce a convincing illusion, as in the unusual portrait below at right, disguise the edges of the cutouts by the same method as for black-and-white montages. Retouch any white edges before paste-up with gouache of the appropriate color. A mismatch of lighting will show up especially clearly in color, so be ruthless in your selection of images to combine.

Kaleidoscopic montages, such as the one below at left, generally work best when the final effect is strongly abstract. Simply have four prints made from the same negative – two normal and two with the emulsion side reversed – and mount them to make a symmetrical pattern. To preview the effect, try using two mirrors propped against each other at either side of the original print.

Another approach is to combine color with monochrome, as illustrated opposite. Or you can carry hybrid imagery still further by blending photographic prints with other media – for example, images cut out of magazines.

A feather globe (above) against a background of clouds makes a harmonious, kaleidoscopic pattern. The starting point was a photograph of palm trees, taken with the camera angled. The photographer made four prints from the negative – two of them with the emulsion side reversed. He trimmed the prints and mounted each of them on one quarter of a square of cardboard.

President Lyndon Johnson (right) makes a startling appearance in the famous painting "American Gothic". First, the painting was photographed in the gallery where it hangs. The montage artist then made a carefully proportioned enlargement of a presidential photographic portrait and cut out the head so that it would fit neatly onto the painted farmer's shoulders.

A cellist in a red room (right) adds color and movement to a jumble of gray buildings. The photographer kept white edges around some buildings to give the montage a stagey feel.

Mutilating transparencies

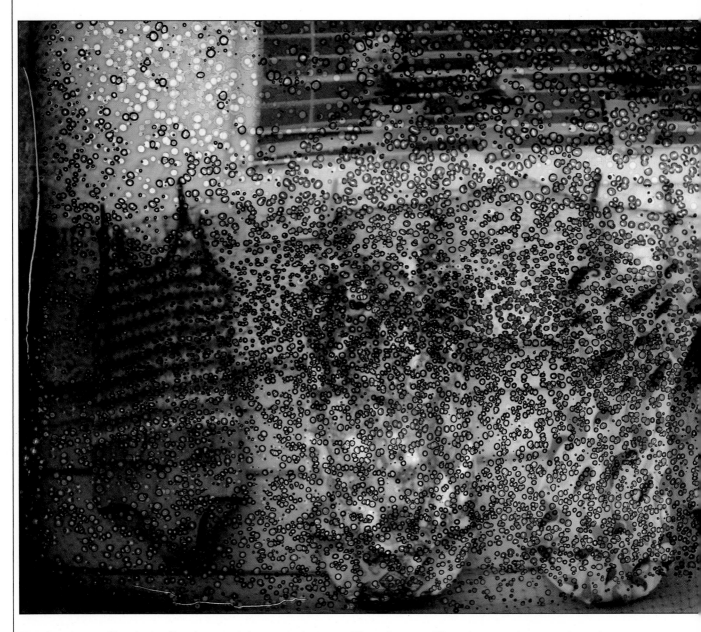

Transparency film is easily damaged by scratches, heat or chemicals. Normally, such damage is unfortunate. However, controlled mutilating techniques can produce exciting new images. Because results are always unpredictable, it is best to make several copies of a slide so that you can experiment freely with different effects.

Heat produces some of the most dramatic alterations. Hold the slide with tweezers and move it gently back and forth a few inches from a low flame. The emulsion will start to melt and then coagulate into bubbles of color, which will spread and swirl together. At the same time, the surface of the slide will pucker up. The pictures above and on the opposite page, below, show the sort of effects that heat can achieve.

Another technique is to use a needle or craft knife to scratch away emulsion layers of dye in selected parts of the image, as in both the pictures opposite. By varying the pressure, you can remove one, two or all three layers to obtain different colors. It is also possible to paint on bleach or an acid to dissolve part of the image. While the emulsion is still soft, you can move the dyes about with a brush or with a small blunt tool such as a screwdriver to further change the composition.

Crisscrossing lines (left) and a wash of deep red form a dynamic abstract. The photographer scratched an unexposed, processed slide with a scalpel and projected it onto a screen with a red filter partially covering the projector lens. He then photographed the result.

A small boat (below), almost hidden in black hail, plows through rippling waves. The photographer added the "hail" by heating the slide over a low flame, and then scratched the emulsion to create the blue and white "sea".

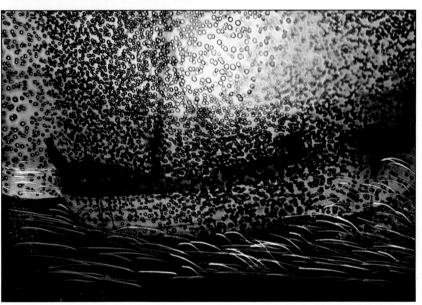

Bathing suits on a clothesline (above) appear to float through bubbling water. The photographer gave the image a new dimension of pattern and texture by passing the transparency, emulsion side up, back and forth over a flame. Heating caused the melting dye layers to separate into globules.

Transposed processing

Interesting distortions of color and tone result when film and processing are mismatched. If you do not have a darkroom, you can still achieve these effects by taking your film to a custom laboratory.

The simplest transposing method is to print regular color slides on color negative paper. Because you are starting with a positive image, the result is a negative color print. The image will have very high contrast, with a loss of detail in both highlight and shadow areas, and brilliant, reversed colors. The two pairs of pictures opposite demonstrate this effect. A variation on this technique is to print infrared transparencies onto color negative paper. Some colors will appear as normal but more intense, while others will record in vivid, unnatural hues. If, for example, you choose a subject with green vegetation and blue sky or water, you will get a negative print with brilliant greens and yellows.

To obtain color distortion in a slide, the transparency film can be processed in color negative chemicals. Again, the result is a negative image, but the color reversal is never exact, because transparency film does not have a built-in orange mask for correcting color balance in printing, as color negative film does.

Whichever transposing technique you choose, the effect will be most dramatic if the subject's normal colors are familiar. For example, in the picture below, it is not immediately obvious that the colors of the sails are reversed – but the strange hues of the sea and sky are evident at once. To ensure good results with transposed processing, avoid over-contrasty lighting of the subject, and remember to bracket your exposures.

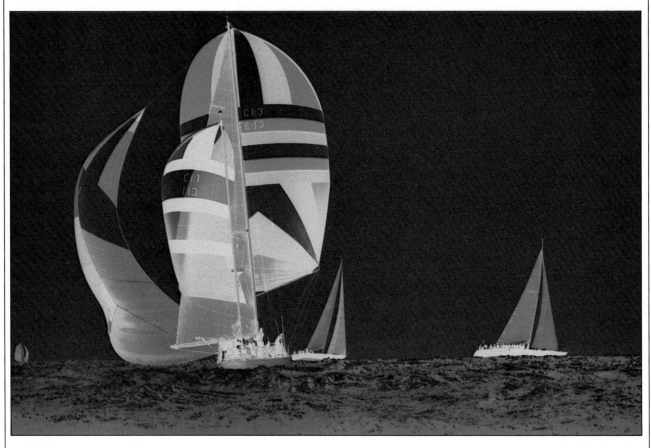

Brightly colored yacht sails
*against a plain seascape provided an
ideal subject for transposed processing.
The photographer took the picture using
Ektachrome film and developed it in
color negative process C-41 to obtain
this negative slide with its strong
semi-abstract shapes.*

A woman in a bathing suit
(left) paddles in a lurid orange pool.
Printing a transparency (shown above)
onto color negative paper gave the scene
unnatural hues. The strange colors
combined with the oblique overhead
viewpoint to produce an original and
offbeat image.

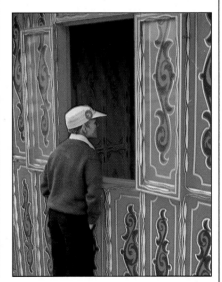

Decorated panels *(left) appear as*
intense blue in a transposed print, made
by printing the slide shown above on
color negative paper. The inherently
high contrast of transparency film
converted the extreme shadow and
highlight areas of the image to
featureless black-and-white.

Glossary

Anamorphic lens
A lens that uses prisms or cylindrical elements to compress an image vertically or horizontally, taking in a longer or wider view. The resulting image thus looks stretched or squashed, but can be restored to its normal appearance during printing or by projection through a similar lens.

Color correction filter
A comparatively weak color filter that corrects for small differences between the color temperature of the illumination used for a particular exposure and that for which the film was manufactured.

Copier see SLIDE COPIER

Diffraction filter
A colorless filter inscribed with a network of parallel grooves. These break white light up into its component colors, giving a prism-like effect to highlights.

Diopter
Unit of measurement used to describe the power of a lens, defined as the reciprocal of the focal length expressed in meters. The term is used in photography to denote the strength of supplementary close-up lenses.

Double exposure see MULTIPLE EXPOSURE

Extension tubes
Accessories used in close-up photography consisting of metal tubes that can be fitted between the lens and the camera body to increase the distance between the lens and the film.

Fisheye lens
An extreme wide-angle lens with an angle of view up to 180°, or even beyond. Such lenses produce highly distorted, circular images, cropped in all but the widest-angle fisheyes to a square or rectangular image by the film format.

Fluorescent light
Light from a fluorescent lamp, which consists of a tube coated internally with a fluorescent material such as phosphor and containing mercury vapor. This combination produces ultraviolet radiation and emits visible light. Photographs taken without a filter on daylight film in fluorescent light have a greenish cast.

Graduated filter
A filter in which a clear and a colored half blend gradually into each other.

Infrared
Electromagnetic radiation of a wavelength longer than that of visible red light. Infrared radiation can be recorded photographically on specially sensitized film, in either color or black-and-white, to produce eye-catching special effects.

Macro lens
A lens specifically constructed for close-up photography. Macro lenses can also be used for photography at ordinary subject distances.

Masking
The act of blocking out light from selected areas of an image. Homemade cardboard masks placed over the camera lens can be useful for some double-exposure techniques.

Multi-image filter
A filter with multiple facets cut on one side, used to produce overlapping images of the subject.

Multiple exposure
The recording of two or more images on the same frame of film. This can be achieved in a number of ways. Some cameras have a multiple exposure control that lets you recock the shutter without advancing the film. On cameras without this facility you can recock the shutter after pressing in the rewind release, keeping the film taut by constant pressure on the rewind lever. Another technique is to expose the same film twice, taking care to align it so the frame positions match up for the second exposure.

Neutral density filter
A gray filter used to cut the amount of light entering the lens without affecting color balance.

Painting with light
The technique of firing a flash several times at different points around a subject during one exposure.

Panning
The technique of moving a camera to follow the motion of a subject, used to convey the impression of speed or to freeze action at slower shutter speeds.

Polarizing filter
A filter that changes the vibration pattern of light passing through it, used chiefly to remove unwanted reflections from a photographic image or to darken the blue of the sky.

Push-processing
Increasing development time or temperature during processing, usually to compensate for underexposure in the camera or to increase contrast. See UPRATING

Retouching
Handwork done on negatives, prints or transparencies, usually with a brush and special retouching fluid, to disguise flaws or otherwise improve or alter the image.

Reversing ring
A device for attaching a lens back to front to the camera body, to maintain good definition in close-up photography.

Sandwiching
Combining two or more negatives or slides to produce a composite image, either on one sheet of printing paper or on a slide-projecting screen.

Slide copier
A device incorporating a lens, a camera mount and a slide holder, used to make duplicates of transparencies.

Split-field close-up lens
A lens attachment that consists of half a close-up lens fitted into a rotating mount. The attachment is used to keep foreground subjects that are close to the camera in sharp focus, without sacrificing sharpness in the background.

Starburst filter
A filter with crossed horizontal and vertical lines etched into its surface. Any sharp point of light viewed through the filter forms radiating lines of light, resembling a star.

Stop
A comparative measure of exposure. Each one-stage change of the shutter speed or aperture (for example, from 1/60 to 1/125 or from f/2.8 to f/4) represents a stop and doubles or halves the amount of light reaching the film.

Supplementary close-up lens
A simple lens used as an accessory for close-ups. The supplementary lens fits over a normal lens to produce a slightly magnified image.

Tungsten light
A common type of electric light for both domestic and photographic purposes. Tungsten light is much warmer (more orange) than daylight or electronic flash. When using daylight-balanced film in tungsten light, you must use a filter to reproduce colors accurately; alternatively, you can use special tungsten-balanced slide film.

Uprating
Setting a film speed index on the camera higher than that at which the film was designed to be used. Photographers often uprate to cope with dim light: they underexpose and then make an appropriate compensation by increasing, or "pushing", the development time.

Zooming
Altering the focal length of a zoom lens during exposure to create a blur suggestive of movement.

Index

Acknowledgments

Picture Credits

Abbreviations used are: t top; c center; b bottom; l left; r right.
Other abbreviations: IB for Image Bank, SGA for Susan Griggs Agency.
All Magnum pictures are from The John Hillelson Agency.

Cover Alfons Iseli

Title Tim Brown. **7** John Sims. **8** De Lory. **9** Phil Jude. **10** Michael de Camp/IB. **11** Ben Rose/IB. **12** Julian Nieman/SGA. **13** H.P. Dimke/IB. **14** De Lory. **15** Chris Alan Wilton. **16-17** Fotogram. **18-19** De Lory. **19** t John Sims, b Uli Butz. **20-21** all Elliott Erwitt/Magnum. **22** t Robin Laurance, b Anne Conway. **23** t Jerry Young, b Richard Platt. **24** De Lory. **25** tl H. Wendler/IB, bl Robin Bath, r De Lory. **26** Lance Nelson/SGA. **27** l Robin Bath, r De Lory. **28** t John Freeman, b Horst Munzig/SGA. **29** De Lory. **30** John Freeman. **31** t Robin Bath, b Ceri Norman. **32-33** John Sims. **33** De Lory. **34-35** Richard Oliver/Xenon. **35** t Lawrance Lawry, b John Sims. **36** Lawrence Lawry. **37** De Lory. **38** l Richard Haughton, r John Hedgecoe. **39** Richard Haughton. **40-41** De Lory. **42** t Geoff Gove/IB, b De Lory. **43** t De Lory, b Francisco Hidalgo/IB. **44** De Lory. **44-45** Leo Mason. **45** t Francisco Hidalgo/IB. **46** t Ron Sauter/IB, l Richard Haughton. **47** Nick Boyce. **48** Richard Platt (Band of 2nd Battalion The Queen's Regiment). **48-49** Tim Stephens. **49** Michael Freeman. **50** John Sims. **51** t Robert Eames, b Ed Buziak. **52** Ed Buziak. **52-53** Tony Jones/Robert Harding Picture Library. **53** l Mitchell Funk/IB, r Richard Haughton. **54** Fotogram. **54-55** Alma Samuels. **56** l De Lory, r Clive Boursnell. **57** Photri/Robert Harding Picture Library. **58-59** Ed Buziak. **59** t John Hedgecoe, b Geoff Gove/IB. **60** Robin Bath. **60-61** Tom Grill/SGA. **62** Nick Boyce. **62** Richard Haughton. **62-63** Timothy Woodcock. **63** t Ian McKinnell, b Timothy Woodcock. **64** John Sims. **64-65** John Heseltine. **65** Carol Joggs/Robert Harding. **66** Fiona Pragoff. **67** Timothy Woodcock. **68-69** Ray Massey. **70** l Obremski/IB, r Julian Nieman/SGA. **71** Red Saunders. **72-73** Michael Freeman. **73** John Wylie/Robert Harding Associates. **74** Phil Jude. **74-75** Julian Nieman/SGA. **76** l Julian Nieman/SGA, r Gabe Palmer/IB. **77** Chris Alan Wilton. **78** Tessa Traegar. **79** t Michael de Camp/IB, b Mari Mahr. **80** Michael St Maur Sheil/SGA. **81** tl Ian McKinnel, bl Julian Nieman/SGA, r Lawrence Lawry. **82** John Hedgecoe. **83** l Michael de Camp/IB, r De Lory. **84** l De Lory, r Chris Alan Wilton. **85** John Hedgecoe. **86-87** Laurie Lewis. **88** l Richard Haughton, r Alastair Black. **89** Alastair Black. **90-91** Richard Haughton. **91** t Richard Haughton, b John Heseltine. **92** Ian McKinnell. **92-93** Mitchell Funk/IB. **93** Mitchell Funk/IB. **94-95** Tel Seago. **95** t John Hedgecoe, b Tel Seago. **96** l Monique Fay, r Alfred Gescheidt/IB. **97** Julian Nieman/SGA. **98-99** all Neill Menneer. **100** Alastair Black. **101** all Nick Boyce.

Additional commissioned photography by John Miller

Acknowledgments Keith Johnson Photographic, Nikon UK, Pelling & Cross, The Widescreen Centre

Artists David Ashby, Roy Flooks

Retouching Roy Flooks

Kodak, Ektachrome, Kodachrome and Kodacolor are trademarks